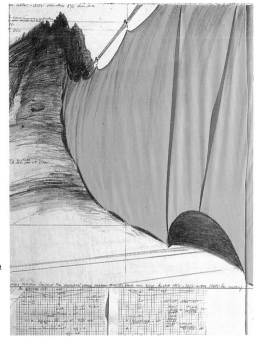

Preceding page: Christo in Kansas City, 1978. (photo: W. Volz)

Valley Curtain, Project for Rifle, Colorado. Collage, 1972, 28″ × 22″. (photo: Eeva-Inkeri)

All rights reserved under International and Pan-American Copyright Conventions. Published in the United States by Pantheon Books, a division of Random House, Inc., New York, and simultaneously in Canada by Random House of Canada Limited, Toronto.
Originally published in France by Flammarion , Paris. Copyright © 1985 by Art-Press/Flammarion.

Library of Congress Cataloging-in-Publication Data
Laporte, Dominique G.
 Christo.
 Translation of: Christo.
 Bibliography: p.
 1. Christo, 1935– —Criticism and interpretation.
I. Title.
N7193.C5L3613 1985 709′.2′4 85-42908
ISBN 0-394-54597-4

We would like to give special thanks to Christo and Jeanne-Claude Christo for all their help in the realization of this book.

Since this page cannot legibly accommodate all permissions acknowledgments, they appear on page 87.

Manufactured in France by Maury-Imp., S.A.
Designed by Naomi Osnos

First American Edition

DOMINIQUE G. LAPORTE

Translated from the French by Abby Pollak

Christo

PANTHEON BOOKS, NEW YORK

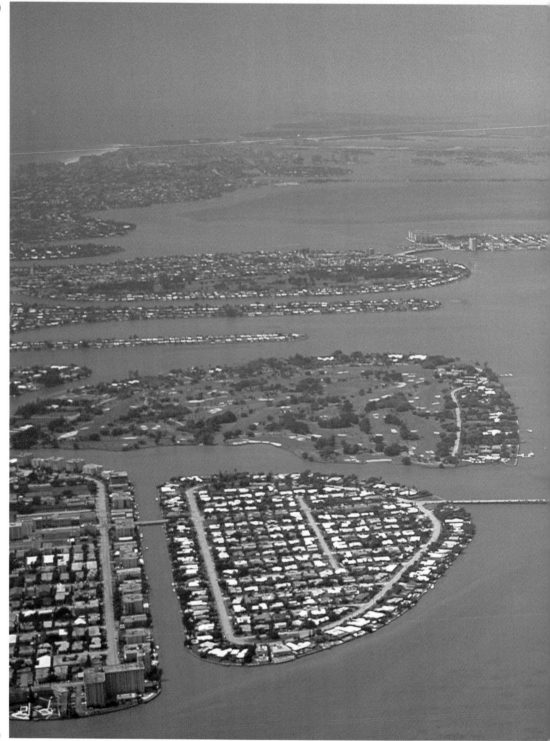

The technical descriptions of the works and projects by Christo which appear on these pages are on pages 81–84.

Surrounded Islands, Biscayne Bay, Greater Miami, Florida, 1980–1983. (photo: Jeanne-Claude)

4

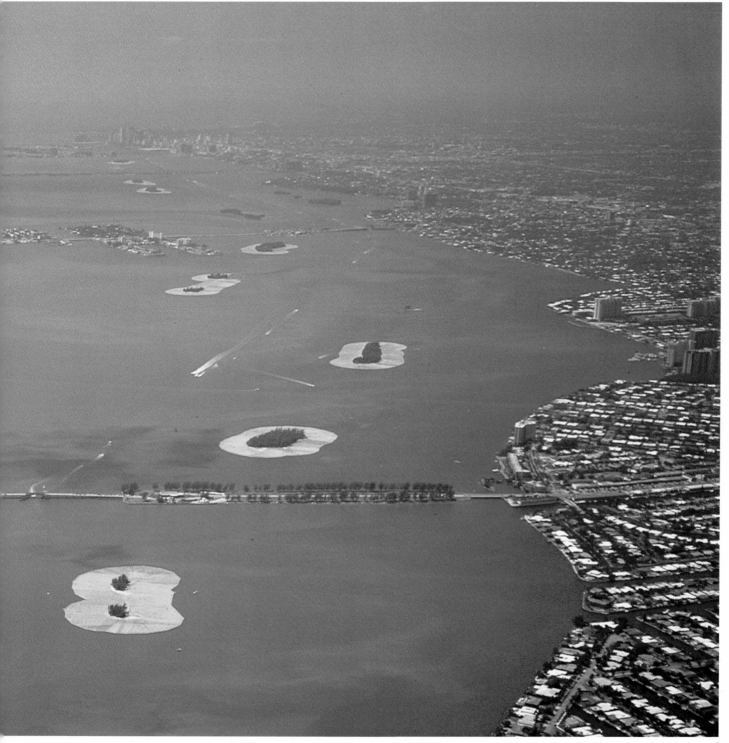

5

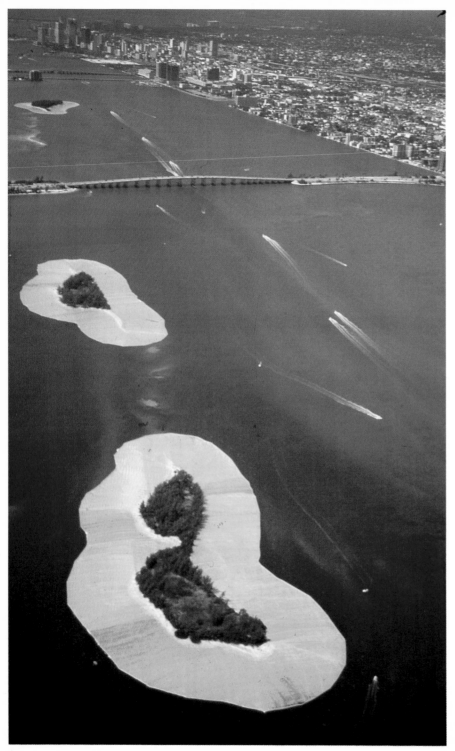

Surrounded Islands, Biscayne Bay, Greater Miami, Florida, 1980–1983. 6,500,000 square feet of floating pink polypropylene fabric. (photo: W. Volz).

(photo: Jeanne-Claude)

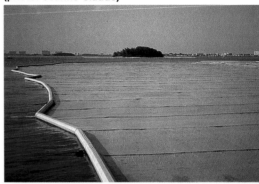

(photo: Jeanne-Claude)

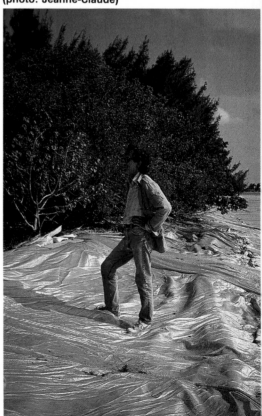

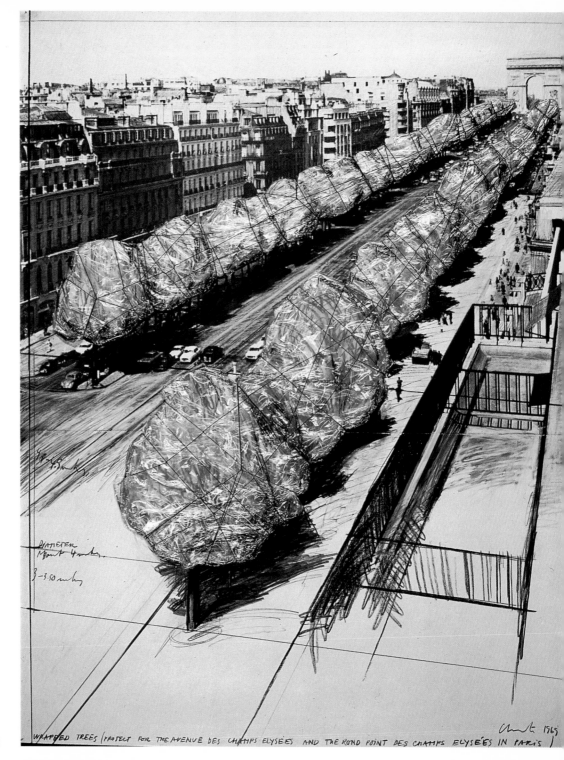

Wrapped Trees, Project for the Avenue des Champs-Elysées, Paris. Collage, 1969. 28″ × 22″. Pencil, polyethylene, twine, charcoal, pastel, crayon, and photostat. Private collection, France. (photo: Eeva-Inkeri)

Opposite: **Wrapped Walk Ways, Loose Memorial Park, Kansas City, Missouri, 1977–1978.** 143,000 square feet of orange nylon fabric. (photo: Jeanne-Claude)

WRAPPED TREES (PROJECT FOR THE AVENUE DES CHAMPS ELYSÉES AND THE ROND POINT DES CHAMPS ELYSÉES IN PARIS)

Christo 1969

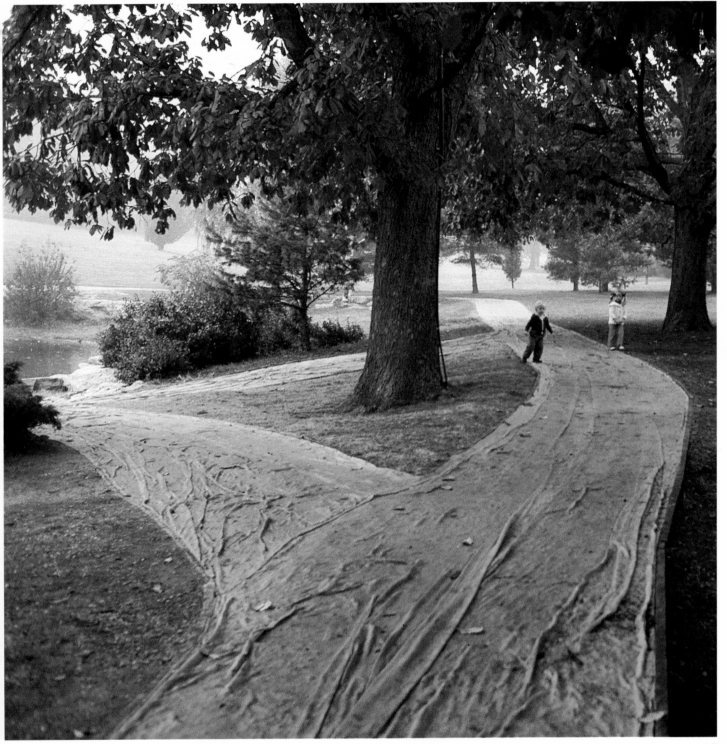

Right:
Running Fence,
Sonoma and
Marin Coun-
ties, California,
1972–1976.
165,000 yards
of woven white
nylon fabric.
(photo. B. Laur-
itzen)

Opposite:
Running Fence,
Sonoma and
Marin Coun-
ties, California,
1972–1976.
(photo: W.
Volz)

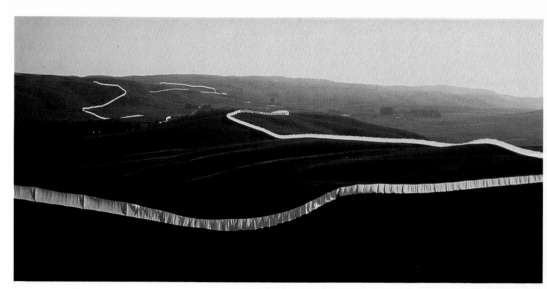

Below:
The Wall—
Wrapped Ro-
man Wall,
Rome, 1974.
Via Vittorio Ve-
neto and Villa
Borghese.

Woven syn-
thetic fabric
and rope.
Height: 50 feet;
length: 850
feet. (photo: H.
Shunk)

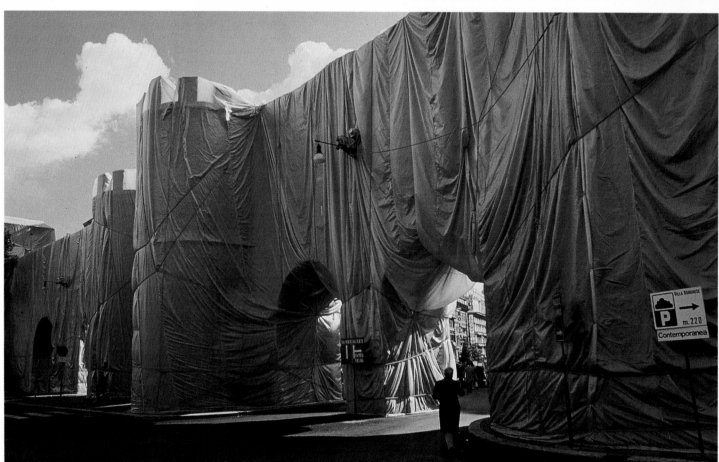

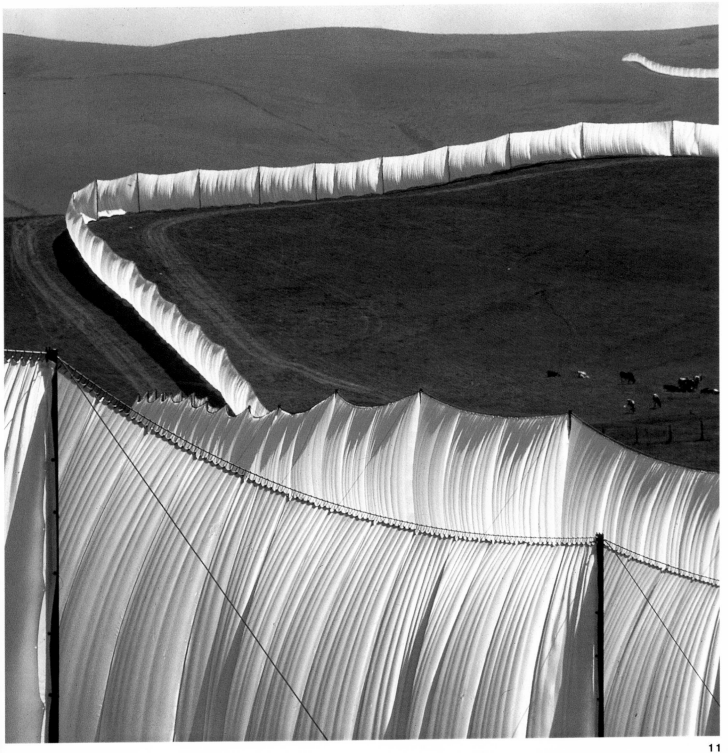

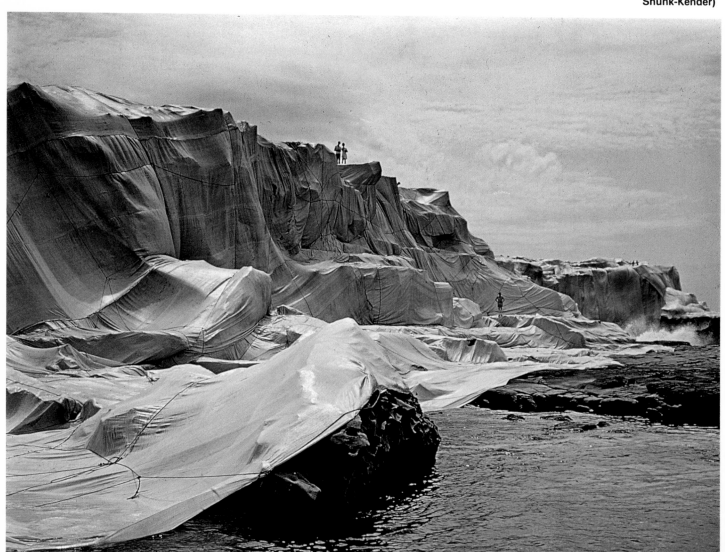

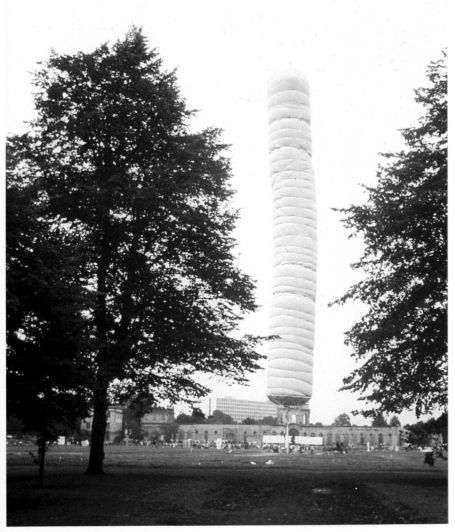

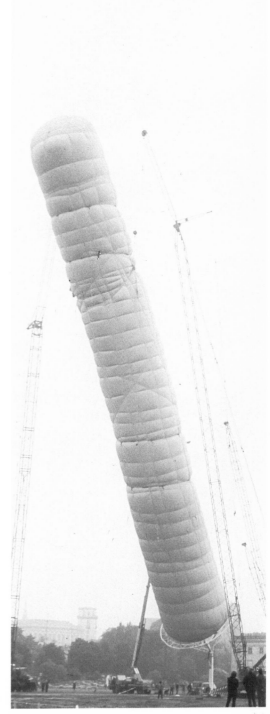

5,600 Cubic Meter Package, Documenta IV, Kassel, West Germany, 1968. Height: 280 feet. Diameter: 33 feet. 22,000 square feet of fabric and 12,000 feet of rope. Weight: 14,000 pounds. (photo: K. Baum)

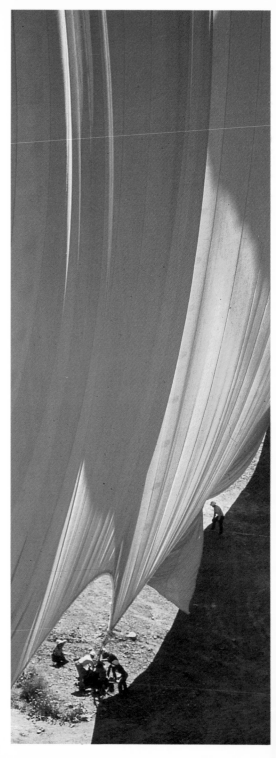

Valley Curtain,
Rifle, Colorado,
1970–1972.
200,000 square
feet of nylon
polyamide.
(photos: Shunk
Kender)

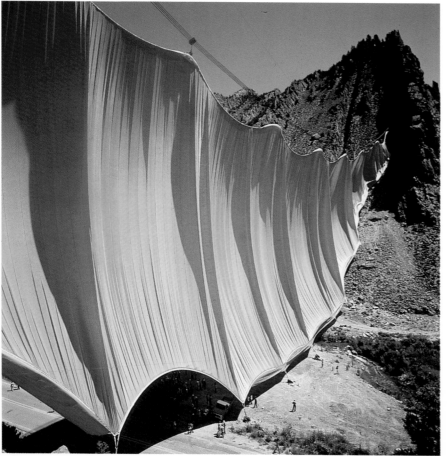

Four Store Fronts (Parts 1 and 2), 1964–1965. Galvanized metal, clear and colored plexiglass, masonite, canvas, and electric light. Height: 8'1½" length: 18'8"; depth: 2'. (Photo: F. Boesch)

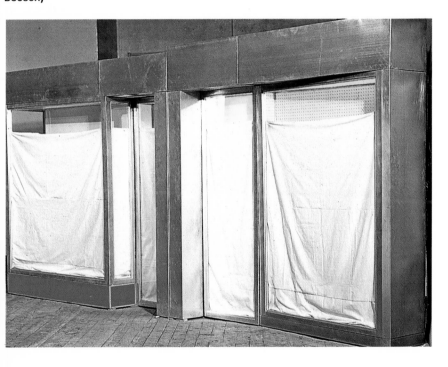

Showcase, 1963. Glass, stainless steel, wrapping paper, tape, satin, and electric light. 47¼" × 31½" × 10". Collection: Rijksmuseum Kröller-Müller, Otterlo, Netherlands. (photo: R. de Seynes)

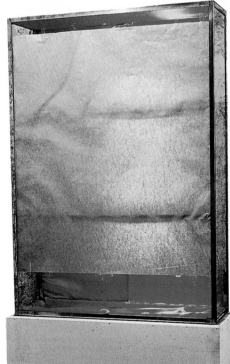

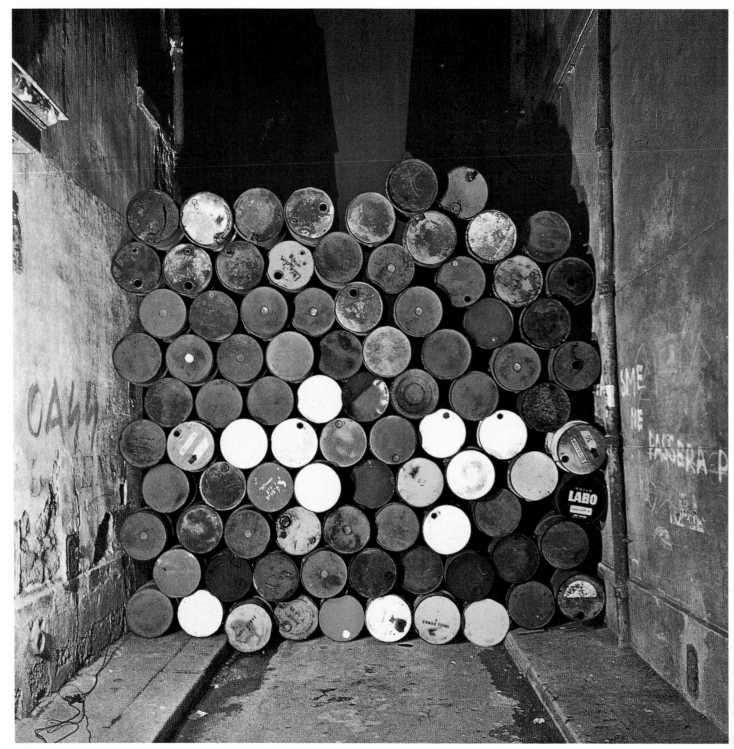

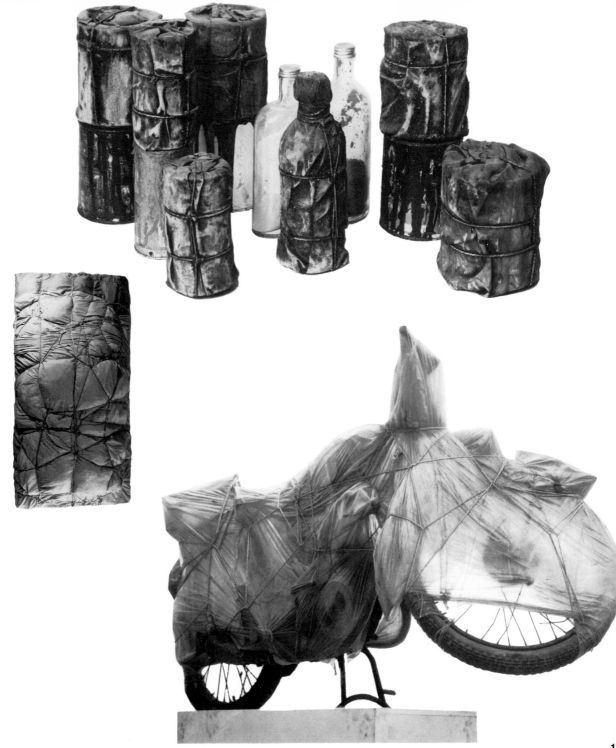

Opposite: Iron Curtain—Wall of Oil Barrels, 1961–1962. Erected in the rue Visconti, Paris, June 27, 1962. 240 oil barrels. 14′ × 13′ × 5′6″. (photo: J. D. Lajoux)

Packed Bottles and Cans, 1958. Cans, bottles, lacquered canvas, enamel paint, twine. 11″ × 29″ × 11″. Collection: Jeanne-Claude Christo. (photo: Eeva-Inkeri)

Package, 1961. Fabric, rope, twine. 32″ × 84″ × 14″. Collection: Jeanne-Claude Christo.

Wrapped Motorcycle, 1962. Motorcycle, polyethylene, and rope. 30¼″ × 76″ × 16″. Private collection, Paris. (photo: W. Volz)

17

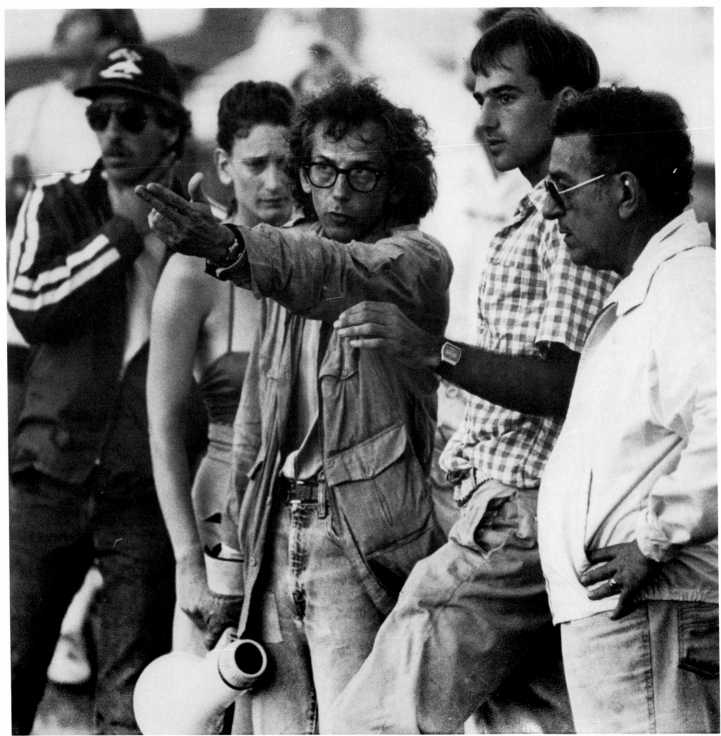

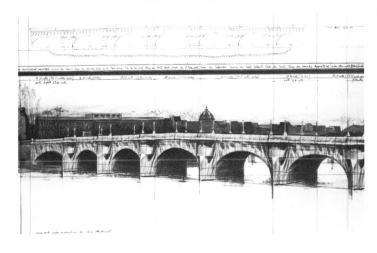

For centuries, there was a sacred dimension to the building of bridges. Was it because the act of crossing a river suggested the violation of a taboo? Or because men were fearful, haunted by the sense of limits reached, then boldly transgressed? For a long time, a feeling of menace, the threat of imminent catastrophe, of the silent, insidious revenge of gods and spirits, of punishment provoked by a world bent on defying its limits, caused men to see the building of bridges as a sacred act. In Roman times, it was accompanied by religious rituals, and for centuries afterwards, builders saw the crossing of rivers as intimately linked to the survival of pagan rites.

In the beginning, then, the building of a bridge was a religious act. It means the raising, stone by stone, of a monument that traversed an obstructive frontier, a limit imposed by gods or nature on the territory of men, on that designated space wherein they might recognize one another, a passage into enemy territory or into a no-man's-land,

a direct crossing of what was perhaps one of the first symbols of time. This irreverence men demonstrated for their world, this sacrilegious daring necessary to effect a breach in time, had to be paid for by an excess of rituals and beliefs. For this defiance of space and time, for this crime against the gods, for this laceration of the mirror of the river, men had to atone.

The wrapping of a bridge in a cloth which robs the stone of its impervious appearance, the paradoxical burying of the durable in the ephemeral, the draping of stone, is also a religious act. All art, in fact, is a religious act. For art is born of religion. From it, art inherits the absoluteness that invests the artist with a mission. Between men and the world, art introduces a dimension of excess, of the useless, of waste. Art is like a remnant of transcendence, what is left after Reason has imprisoned the Supreme Being. Born of religion, art separates itself from it—a late separation, which occurred about the same time as architecture and painting

began to reproduce the heavens on the ceilings of Roman churches—only to find, in the conquest of its own absoluteness, a definition of itself as a religion without referents. The function of art is not to gather men around a belief or a leader; the pure nothingness it incarnates, the emptiness or absence it creates in the social fabric, purges it of that deadly logic necessary to the stirring of masses.

Does it harm stone to wrap it? To wrap for a few days the visible appearance of something enduring, something that transcends the duration of our lives, to wrap the oldest bridge in Paris? Does the wrapping of bridges harm the builders of bridges? Does it harm those who cross those bridges every day? There is the faint suggestion of an irrational fear in this act, as there is in all of Christo's works, a dim presentiment of menace which seems to compel a resistance to this exceedingly simple and singularly gentle endeavor. It is as if wrapping this bridge revived ancient fears, as if the antique menace that once

loomed over the building of bridges suddenly leapt into the memories of those who, in the interim, had forgotten the sin they had been expiating for so many centuries.

From the time of the Roman Empire until the nineteenth century, the odor of expiatory rites accompanied the construction of all works built to withstand the flow of water, that is to say the flux of time. Whatever men did to endure was paid for with lives. Given their grim picture of eternity, men were satisfied to inscribe their names or deeds in something less perishable than their own flesh in order to create an arithmetically advantageous image of immortality. They built monuments with no other purpose than to deny their own death. But what they built in stone, they paid for in lives. That is the ransom stone demands of men. Stone belongs to time; it crumbles and dies, but because men envy its durability, stone will lend it to them on one condition—that they pay tribute in living flesh, that they deposit in the stone itself a living payment.

The building of a bridge, the crossing of the face of time by a monument of stone, requires the ritual sacrifice of a victim. Both Plutarch and Varro trace the derivation of the word pontifex, or pontiff, from the sacrifices offered up on bridges (les ponts). In the time of the Romans, the great architects and builders of Europe, the guardian of religion was called the "builder of bridges," originally a name for the priest who conducted the sacrifices on bridges. Well beyond the Roman Empire— in fact, throughout Europe, from Italy to Scandinavia—in the rites of paganism as in

the beliefs of our own ancestors, the building of bridges was associated with human sacrifice. During the Middle Ages, there were constant allusions to enemy prisoners, slaves, and serious criminals walled up to ensure the stone's resistance to the passage of time. Later, a coffin, an animal, an object—anything that could be metonymically considered an immolated victim—was substituted for the human being. "In modern Greece," Frazer wrote at the end of the nineteenth century,

when the foundation of a new building is being laid, it is the custom to kill a cock, a ram, or a lamb, and

to let its blood flow on the foundation-stone, under which the animal is afterwards buried. The object of the sacrifice is to give strength and stability to the building. But sometimes, instead of killing an animal, the builder entices a man to the foundation-stone, secretly measures his body, or a part of it, or his shadow, and buries the measure under the foundation-stone; or he lays the foundation-stone upon the man's shadow. It is believed that the man will dies within the year.

All stone structures that claim to defy the passage of

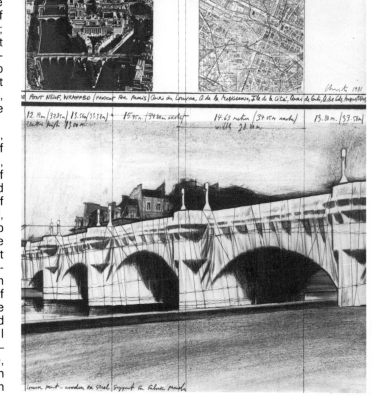

20

time—bridges, châteaux, ramparts, constructions that define, cross, or defend frontiers, walls that delimit the zones of the possible and the unknown—require a human life within them. An immolated life. It is as if they needed this awesome and spectral presence walled up alive in the deepest part of their stony being in order to withstand the passage of time, in order to endure beyond the duration of our lives.

What does it mean to drape a cloth over stone? What is he doing, this man who shrouds a monument of stone that defies time? Is he pretending to bury the stone itself, or does he want to signify the death of an abiding monument that perhaps demanded a sacrifice of flesh? What does he want to suggest, this man who turns stone arches into phantoms, arches that may contain his body or the shadow of his body? And when he dresses a rocky shore in a fabric so white that the coast seems to become its own ghostly double, what is he doing? What is he doing when he builds a wall of fabric rising from or plunging into the ocean, a wall far too slender to contain a body, a wall like a vertical waterfall whose streams run throughout the countryside?

To drape a silken cloth over a structure that spans a river-frontier, to turn the stone itself—not the soul or the shadow of the person immolated—into a phantom, is a kind of reverse sacrifice. Whereas the building of a wall calls for, presupposes, even demands a holocaust, the wrapping of stone should be interpreted, not as a desire for the stone's death, but as the obliteration of what the stone demands. As early as 1974, Christo had already wrapped an entire section of the wall that borders the Villa Borghese in Rome. Today, we still consider the Romans the greatest builders of all time, which makes them also the mightiest conquerors, and thus the greatest immolators, those who played with human lives in the Colosseum, who surrounded their empire with limes, fortified stone walls that stolidly defined for the other—the alien, the "barbarian"—the boundary not to be transgressed.

Insofar as art is a religion without referents, veiling a wall, wrapping the stone that crosses the water, that spans and defies the flow of time, raising a great wall of cloth, are religious acts, reverse sacrifices. What is implied in the draping of the Pont-Neuf? What is signified when this monument is wrapped, and thus transformed into sign, into exchangeable object, like the goods just a few steps in the Samaritaine department store? On trouve tout à la Samaritaine—"you can get anything you want at the Samaritaine"—the French say, even the Pont-Neuf! Wrapping reveals the exchangeability of things; it designates the object wrapped as commodity, as sign. Yet wrapping neither abolishes the object nor hurts the stone; on the contrary, it exposes for all to see the human lives contained inside. Christo's act repels some people because it reveals the very concept of stone. By draping the stone in fabric, he unmasks it. What is important, however, is not the fact that wrapping the Pont-Neuf abolishes its function or endows the bridge with an exchange value like that of any other package. It is not the annihilation of its normal appearance or its use value, not the image of the bridge as phantom, but the fact that this act changes the signification of the Pont-Neuf. It no longer signifies as stone or as a concept of stone that

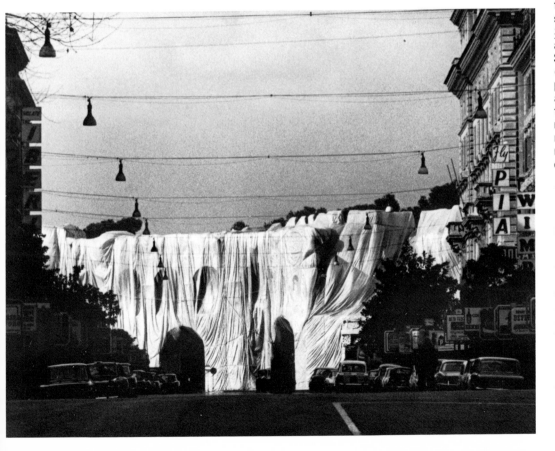

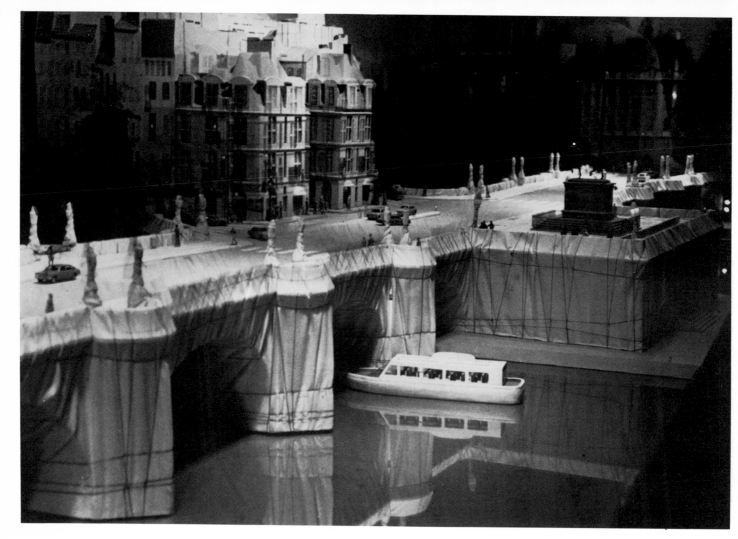

immolates, but purged of its matter, it signifies in the only sense that remains—its name. In wrapping the Pont-Neuf, Christo makes the name alone a signifier.

Once the Pont-Neuf has been wrapped, draped in the ghostly form whose name is its only signifier, it can no longer be called the Pont-Neuf. The bridge itself, or rather the bridge as matter, is not abolished, but the name now signifies something new to the spectator. For a mo-

ment, Christo erases the stone, covers it in sheet or shroud, and once this happens, the concept is destroyed so that the sensuous experience associated with the name may be renewed, an experience attached to the arbitrary signification of the Pont-Neuf as the oldest bridge in Paris. It is not merely a new perception that is created, but one now united with the paradox of the name. In wrapping the Pont-Neuf, Christo destroys its demands for sacrifice and

renews our visual experience of a monument purged of its holocaustal element.

A bridge is, of course, a bridge. It crosses a natural frontier that symbolizes the flow of time. It demands sacrifice. Christo was born in a frontier; his name alone places him at the mercy of this boundary between life and death, death and resurrection, presence and memory, disappearance and return. Born in Bulgaria, Christo spent his childhood in a country

The Pont-Neuf Wrapped, Project for Paris. Scale model, 1981 (detail). (photo: E. Glunz)

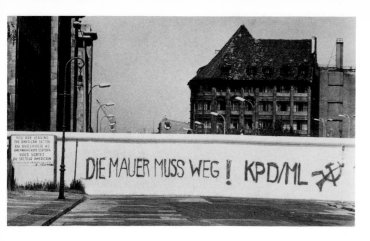

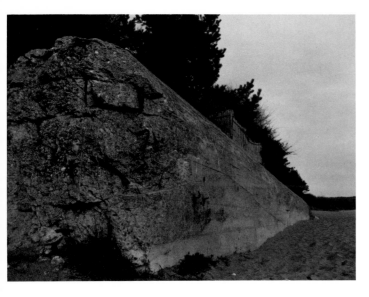

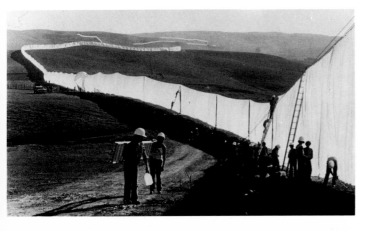

whose frontiers had been violated by men obsessed as never before in history by the phantasm of stone. Everywhere they went, the invaders left walls, their aims of territorial expansion equal only to their claims to immortality. The mad dream of the Third Reich—that it would last a thousand years—can be understood in these words: How many lives did it take to build the Atlantic Wall? To dream of the warrior, of the male, is to become a wall, preferably a great wall, a great erection. The holocaust is to the blockhouse as the immolated victim was to stone, to fortifications, to walls. When a society abandons ritual sacrifice, when a culture represses its rituals of human immolation, there is every chance that this practice will return on a larger scale—one of masses, of whole nations and races.

Born in Nazi-occupied territory, Christo had scarcely turned nine at the end of 1944, when Soviet forces invaded Bulgaria in order to liberate it. (History makes strange euphemisms.) More than by its literature or its music, a society defines itself by its architecture, by group after group of grand designers and builders. When the platforms from which heads of state address the people come to resemble watchtowers, we can be sure that the fences around the camps will not be made of canvas. They will have the same hard consistency of the things that rip canvas and flesh, and they will have double strands of barbed wire—a ghastly redundancy. This is the insane dream of immortality in stone, in a monument, in an empire seeking to last a thousand years.

The fact that Christo was born on a border does not mean he spent his childhood divided between two countries. He was, in a manner of speaking, born on the frontier of his own work; it is his work that shows us just what kind of border this was. Listen

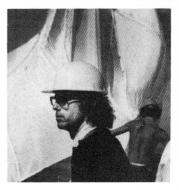

Christo during the construction of Running Fence, 1976. (photo: W. Volz)

**Top:
The Berlin Wall. (photo: L. Freed, Magnum)**

**Middle:
Atlantic Wall, beach of La Courance, Saint-Marc, France. (photo: J. F. Richard)**

**Bottom:
Running Fence. (photo: W. Volz)**

23

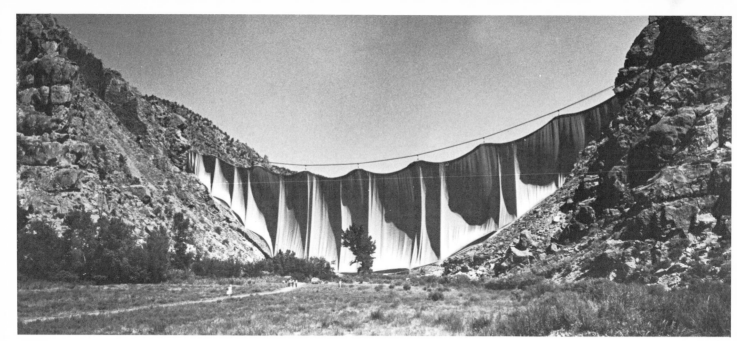

Valley Curtain. (photo: Shunk-Kender)

Below: The Wall—Wrapped Roman Wall, Rome, 1974. (photo: H. Shunk)

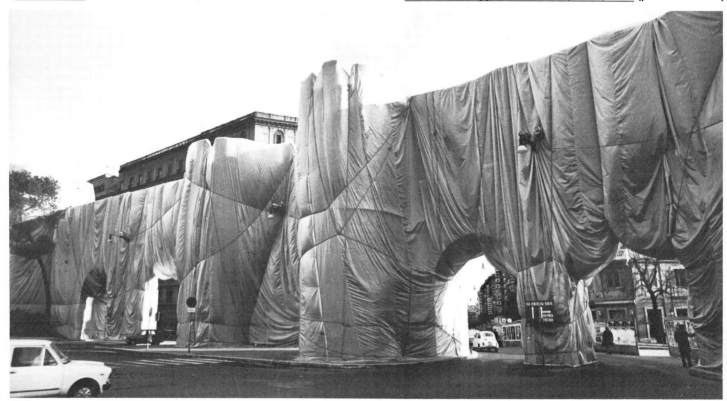

carefully to the titles: <u>Valley Curtain, The Wall</u>. Christo was born on the line that divides the world in two. Exactly twenty years after the clandestine border crossing that led him first to Vienna, then Geneva, and finally Paris, Christo built his <u>Running Fence</u>, a work as serpentine and unpredictable as the border itself. The fence, the barrier, the runnning frontier. Twenty years later, the repressed frontier has returned, now a ghostly apparition of the wall that has cut the world in two, the patient and almost unconscious revenge of a man who, in his ephemeral work, defies the sacrificial rite that literally immured Man in stone.

Christo's art is a political act. He is not, however, a man with a cause; neither is he a pacifist or a militant entertainer. He is a man who makes war in a singular fashion. As reverse sacrifice, his work immolates the very logic of sacrifice in stone. It consumes the stone's desire, indeed demand, for human lives. His gauzy fabrics make the concept of stone apocryphal, insofar as this concept is synonymous with the will to annexation, the desire for immortality spatialized, as it were, in territorial conquest. Christo's <u>Running Fence</u> mocks the polarization of the world. It gives us the phantom appearance of a frontier which, <u>because it desires to be</u> fragile and ephemeral, offers only the image of what it was, and thus attacks and corrodes the real frontier that splits the world in two.

Once upon a time, the world was One. There were, of course, frontiers and walls and wars, but none of these threatened the world in its fundamental unity. Now things

are different: divided in two, the world has virtually reached its breaking point, to borrow a term from mechanical engineering which defines the moment a solid mass is split in half. Our civilization wavers on the verge of world fission, and Christo's work, situated precisely at this limit, seeks not to avert or deny it, but to attack it. In culture and civilization, art is like a body moving through a field of resistance. Christo's work attempts to compel our consciousness to an apprehension of ourselves as mortal, separated from our priapic fantasies of immortality; it attempts to alter our relationship to the world so that we may defy the schism that promises our virtual annihilation.

<u>Valley Curtain, The Wall, Wrapped Coast</u>—what is it saying, this oeuvre that reveals the interchangeability of continents through a simple piece of fabric draped over a rocky shore, this work that represents the reality of whole continents now become interchangeable signs on two sides of a single frontier? Christo's entire future oeuvre is contained in the title <u>Iron Curtain—Wall of Oil Barrels</u>. An iron curtain, a wall, a barrier of oil drums, a shameful barricade of barrels. Twenty-three years ago, in 1962, the year of the Evian Accords and the proclamation of Algerian independence, <u>Iron Curtain—Wall of Oil Barrels</u> was the title Christo gave to his barricade on the rue Visconti in Paris. A wall of oil drums in a city haunted by a new kind of slum, where shacks are built of oil drums. By this act, Christo exposed the impasse, the point of no return reached by a civiliza-

tion so blinded by the politics of denial that it had buried itself, headfirst like an ostrich, in a barrel of refined oil. In 1962, exactly one year after the building of the Berlin Wall, Christo baptized the rue Visconti impasse <u>Iron Curtain—Wall of Oil Barrels</u>: the wall of shame that gave the consistency of stone to a

Who among us knows the length of the Berlin Wall? It is as many kilometers long as there are hours in a day, as many kilometers as there are hours in the rotation of the earth on its axis: twenty-four kilometers. The length of the Berlin Wall is equivalent to the length of time the world needs to go on being itself. It

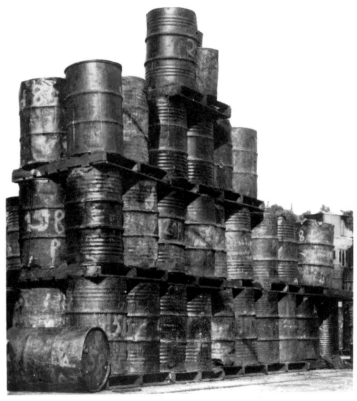

bloody frontier of oil barrels. How many lives were lost for one barrel of oil? How many lives demanded by a wall, the result, geometrically speaking, of an isosceles triangle with Yalta at its apex? The hypotenuse, the Wall of Shame, is the consequence of a dream that the world shall be One, ruled by One man who saw himself incarnated in a thousand-year empire of stone.

Stacked Oil Barrels, 1962. Gentilly, France. 12′ × 55′ × 39′. (photo: R. de Seynes)

is as if the wall had become the imaginary axis around which the world could keep spinning, suspending its problematical perpetuation in time to the peril created by the splitting of its surface, to the imminence of its rupture. The shame of a world divided stretches for twenty-four kilometers.

And how long is <u>Running Fence</u>, the frontier crossed retrospectively by a man fleeing his occupied country? Twenty-four miles long. Arithmetically isomorphic in relation to the Berlin Wall, it is its geometric twin, mirroring the wall like its shadow for

twice its length. In addition, it overtakes the wall, passing it arithmetically. For twenty-four miles is not the true length of <u>Running Fence</u>; its exact measurement is twenty-four and a half miles! This half mile is the space of an irony, a chuckle. The shadow overtakes its mirror image in stone; it exceeds its stone referent yet does not seek to profit from this advantage. And because it overtakes the wall, it disappears immediately. It vanishes into the sea. Ever more distant it runs, ever smaller and frailer, until it plunges, exhausted, into the waves. To its referent in stone,

to the wall of shame it shadows and overshadows, <u>Running Fence</u> holds up a mirror wherein the dividing line between territories annihilates the living earth, burying it in the sea.

If the Wall of Shame can be considered the return of the repressed Atlantic Wall, Christo's work, in its instant internationality (from New York to Paris, from Rhode Island to Abu Dhabi, from the shaded paths of Loose Park in Kansas City to the wall at the top of the Via Veneto), must be understood as the paradoxical revelation of the eternally returning real, its return as a wall of stones wherein the masses come to immolate themselves, blind to the route compelling them to this return, deaf to the words that command them.

It seems to me that Christo's work would not generate so much controversy, would not provoke so much opposition between those fiercely hostile to his projects and those who support them enthusiastically, if it did not attempt to overtake both the real and the repressed. When the wrapped monument vanishes behind its appearance, when it briefly becomes its own ghost before emerging unchanged, Christo is not being amusing or derisive, farcical or ironic. This act transforms the relationship between man and stone; through the altered image of the monument, it changes the way we see our mortality. Intact in substance, unchanged in form, the monument is nonetheless profoundly modified in its reality, which our ordinary vision, blinded by the horror of its return, cannot see.

A reverse sacrifice, Christo's work is also a reverse archaeology. Instead of digging into the earth to exhume buried stones and make them visible to us, he buries, under a piece of cloth, the stone to be reborn. Paradoxically, the stone is now more visible than ever; because of an intentionally fleeting act, the stone as demander of expiation has been abolished. "I seek the involuntary beauty of the ephemeral," Christo has said, words in clear opposition to the battle-hungry paranoia of an empire with plans to endure for a thousand years. Yet Christo is not founding an ideology of the ephemeral; he is creating a <u>work of memory</u> that subverts our arithmetical and linear image of eternity, so dependent on its representation in stone.

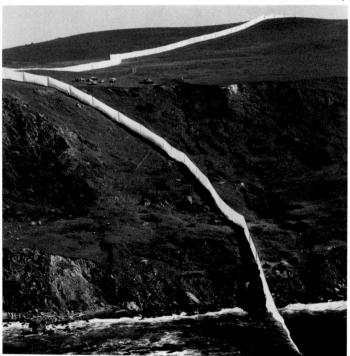

<u>Running Fence</u>. (photo: W. Volz)

Opposite: Ocean Front, Newport, Rhode Island, 1974. 150,000 square feet of polypropylene. (photo: G. Gorgoni)

Wrapped Walk Ways, Loose Memorial Park, Kansas City, Missouri, 1977–1978. (photos: Jeanne-Claude)

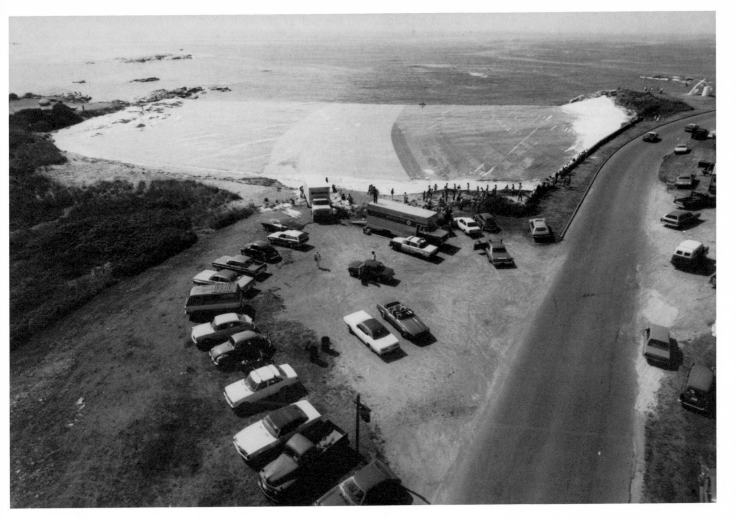

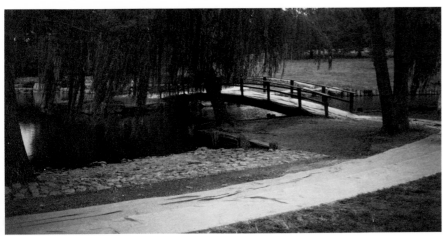

What is most present in these works, particularly in the film on Valley Curtain, is the instant, which is perhaps our only way into eternity, our only connection to a world that opposes the lethal logic of the concept with the joyful presence of the human being. This is a sensuous world, one that offers a different perceptual experience, one where things cease for a rare moment to be univocally connected to a concept, a value, to what the standard perspective defines as a permanent and untransgressible function. For it is not necessarily the palpable, the contour we trace with our finger in the rock, that makes the most lasting impression on us; on the contrary, it is the presence of something that was but that can no longer be found— the fleeting sensation of an odor, a glimpse of something rebellious, untamable, indifferent to our desires. The involuntary beauty of the ephemeral refers to those incomparable moments when an object, a view, a form—in fact, anything at all—appears suddenly, alone unto itself, purged of its everydayness, strangely and eerily beautiful. Something hitherto unseen which we suddenly start to see. Something unrepeatable, something that existed one time only and, because of this uniqueness, is in itself both act and meaning. Something forever inaccessible and forever lost that evokes a feeling of the unreal.

Christo's work compels a strange and puzzling series of questions: "Did that really exist? This photo you're showing me is obviously a photo. It's not a trick. It really happened. But it's not possi-

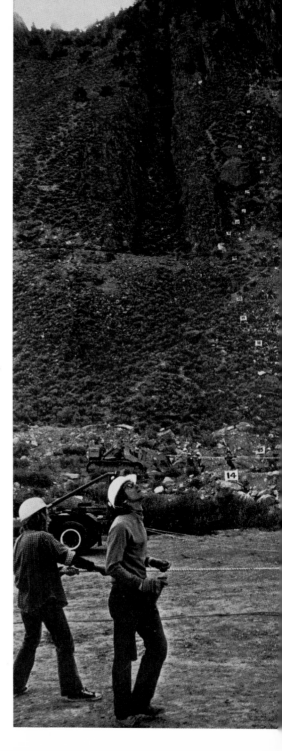

**Valley Curtain.
(photo: H.
Shunk)**

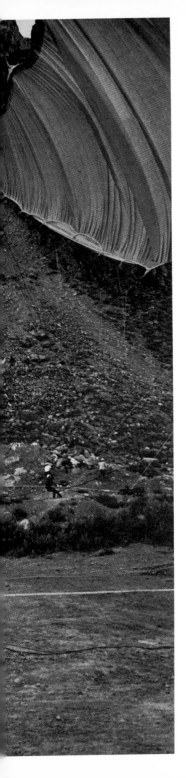

ble; it couldn't have been. Did it really happen? Did he really do that? Did he?" Christo adds the element of absence, of removal, to the monument. Reverse sacrifice, reverse archaeology, his work can also be seen as the flip side of the effect induced by trompe l'oeil. Because the eye sees something that seems unreal, Christo's work paradoxically signifies the real, the real that is unrepresentable, inaccessible to the subjectivity of the consensual perspective. Moreover, the fact that people ask if these things really existed, if the Reichstag was really wrapped, allows us to see what the photograph of a ruined monument, or the sight of the ruins themselves as they were in 1933 and 1945, is incapable of making present. Where all images fail to make us truly see the horror of a reality that our memory represses even as it remembers—in fact, often commemorates—the simple veiling of a monument in a fabric symbolic of both the horror associated with a "thousand-year" empire of stone and the theoretical breaking point of the world succeeds where all other images, all photographs, all documentaries, all fictions—in other words, all representations—fail. For these images only mask the real; in fact, the image is the mask. And all it takes is one mask superimposed on another for the function of the mask itself, or the image, to be abolished.

Did that really exist? This question, provoked by pictures of Christo's work, is linguistically identical with the function of the wrapping that destroys the veiling function of the image. In other words,

because the picture inspires this question about Christo's work (and not about the representations of his work, since the representation <u>exists</u>: real or fake, the image qua image <u>is</u>), it reveals the work's ability to transgress the veiling function of the image. By placing veils almost everywhere, Christo is in effect tearing apart the image-as-veil. What the image represses, Christo reintegrates into our subjectivity, thus forcing us to become either opponents or enthusiasts. "He's a communist," we hear. Or, "He's an opportunist, a representative of Yankee imperialism." Thus do we ourselves imitate our divided world as it prepares to split off from the frontier that divides it.

In provoking this interrogation, Christo's work negates another question we pose of reality. Less than fifty years afterward, when certain people are denying the existence of the camps, at the very moment when the modern imagination refuses the existence of the gas chambers, the Reichstag <u>must</u> be wrapped, for this veil will force our consciousnesses to see what our image of reality—our memory—is already dismissing. Yes, already. Who today knows that stone demands, of its own necessity, the holocaust of an immolated victim? And if we do not wrap our statues and our monuments from time to time, who tomorrow will know that the Third Reich was not the work of a crazed film maker, of a photographer whose shots are so ghastly they must have been faked? Who tomorrow will know that this bloody reality, precipitated ever further into oblivion by each

successive picture of it, was real?

Like the wrapped Reichstag, which exposes the breaking point of a world contemplating its own death, like the mastaba of four hundred thousand oil barrels, which reminds us of the raw materials that compose the funerary chapel we are building to the world, the fabric that covered the Pont-Neuf for several weeks does no harm to the stone. On the contrary, it restores its forgotten truth; it renews by representing the bridge in its name, by purging it of the repressed elements demanding expiation and associated with all stones, all altars, all monuments. In wrapping stone, Christo frees it from what the stone itself conceals. In "imitating" the bridge by making it a wrapped phantom, he shames those who refuse to see in the Wall a mirror of their impending doom. It is time to build a bridge to the past, not to ring down the curtain on it. For all these reasons, we would do well to welcome Christo, the man who shames shame itself.

Overleaf: Wrapped Reichstag, Project for Berlin. Scale model, 1981 (detail). 25½" × 5′ × 6′4″. Fabric, rope, wood, paint, and cardboard. (photo: W. Volz)

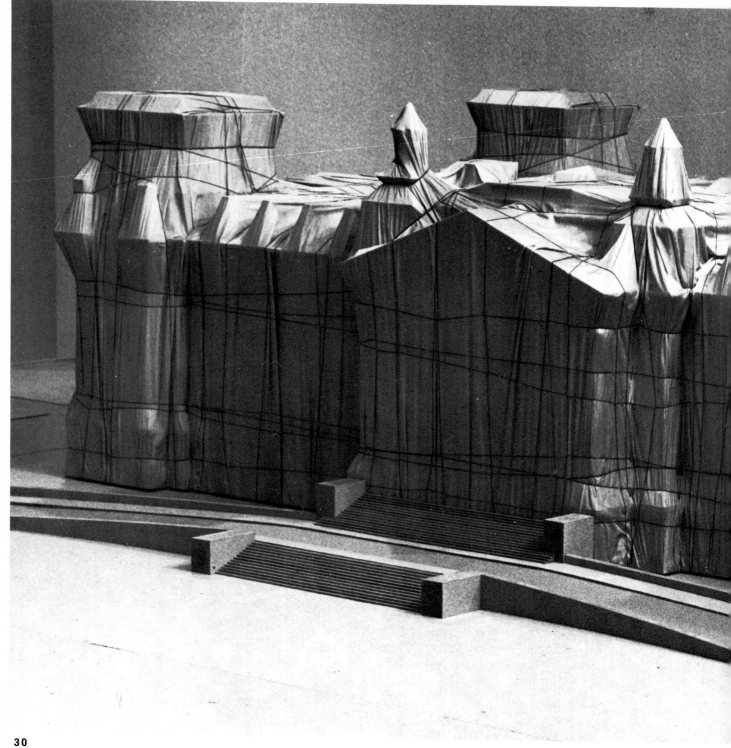

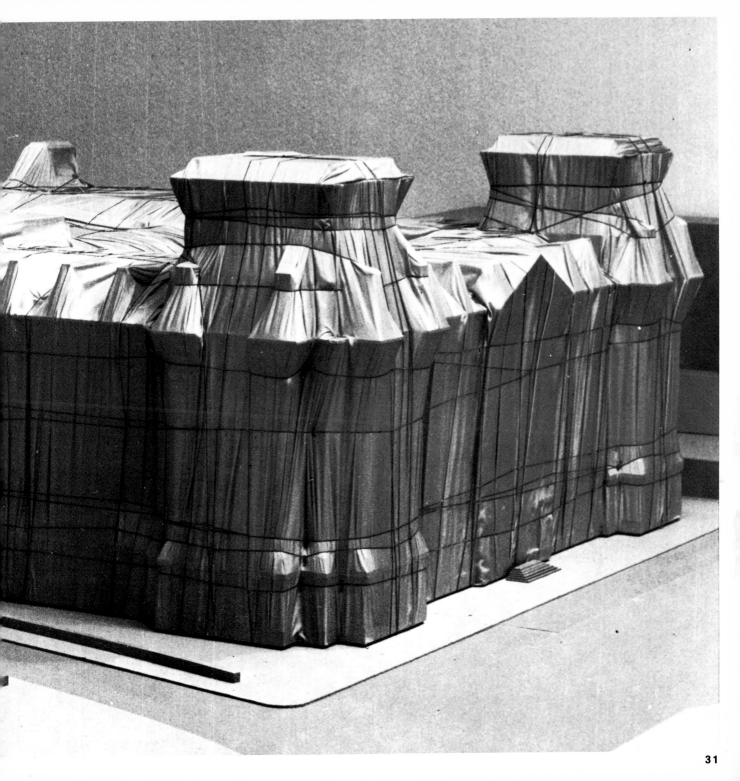

II
THE UNREAL
AND
THE VISIBLE

But why actually go ahead and _realize_ these extravagant projects? Given that there is enough of the uncanny in the designs and drawings, enough distance from familiar forms and landscapes, we cannot help asking why Christo doesn't stop right there. Why does he feel compelled to construct what others would be satisfied simply to _imagine_? There is nothing to keep us from considering these sketches, collages, and models as a complete oeuvre somewhat in the surrealistic or oneiric mode, a sort of phantasmagoric _mise en scène_ that we would accept as the obviously _unreal_. In fact, many would doubtless be happy with the _idea_ alone, with the phantasmagorical image, like the Henry Moore drawing called _Crowd Looking at Tied-up Object_.

Basically, Christo imprints the world with traces of what he could easily confine himself to imagining. In this sense, there is no act more removed from the Western tradition of the imaginary, no bolder challenge to the hegemony of the concept and to the system of meaning that defines our relationship to the world. If we are to understand the importance of Christo's work, we have to imagine Jorge Luis Borges writing his _Ficciones_ as if they were just a series of drafts for a future work, or setting down his stories the way we enter engagements in a datebook. Suppose, for instance, that instead of simply imagining an odd character called Pierre Menard who plunges headlong into the absurd enterprise of rewriting _Don Quixote_, I make this name the pseudonym of someone who, despite the

absurdity of it, actually sits down to do it. Where Christo could simply imagine what he erects, where he could decide to "package" only the images of his phantasms, he, like the real Pierre Menard, actually sets about making visible what appears clearly to be impossible.

When our eye tells us we are seeing a landscape or a monument that _cannot exist_, or that is unthinkable except in the artist's imagination (by definition somewhat lunatic), we are, in effect, bringing into the realm of the perceivable what common sense tells us is purely a product of our imagination. In fact, we can take the analogy one step further, without risk of exaggeration. Suppose that Father Andrea dal Pozzo, who painted on the ceiling of Saint Ignatius the vault of the church opening to the immensity of the heavens, had instead constructed a diabolical machine with an ascending parachute that pulled the church up into its celestial abode. Make no mistake: we are concerned here less with the movement from the impossible to the possible than with the passage from the unreal to the visible. This dislocation of our customarily conservative imaginary mode defies an entire conception of culture; at the least, it is a transgression of everything familiar in the idea, the concept, the vast comfortable universe of designated things.

If it were just a matter of expanding the parameters of the possible, it would probably not be art, but rather technological change at best. Science, after all, has taken charge of making the impossible possible, that is to say,

of exposing the reality inherent in the phantasm. It is quite a different matter when a finished work continues to evoke the unreal after it has left that dimension and entered the realm of the visible. Even when all vestiges of Christo's short-lived works have been erased, traces of their original identities remain in photographs. The works themselves may disappear, but their uncanniness does not. In fact, the more we grow accustomed to what science has snatched from the precinct of the impossible and made possible, the more Christo's art refuses familiarity or domestication. Even as the unreal becomes visible, it remains unreal. In fact, photographs of the work, which "prove" that it did indeed exist outside our imagination, nonetheless compel the question "Did it really exist?" By this question, we are severed from what we know, for despite the testimony of scientific instruments, a suspicion of unreality lingers, defying the certitude of the fugitive object.

In other words, Christo's work effects a kind of reverse trompe l'oeil. Instead of offering us appearance as reality, it includes in its photographic image an element of pure semblance which belies its reality. What, then, is this semblance that refuses to strive for the familiarity of the _likeness_ but, after a brief spell in the domain of the visible, still offers itself as semblance? This enigma has less to do with existence than with the puzzle of _identity_. It is the same question so often asked about poets: "Did Homer really exist? Was Shakespeare really Shakespeare?

Is there really a Borges?"

Perhaps the question "Was this object that I know existed really there?" conceals another, one that has slipped in almost unnoticed: "Is this object really what it is?" Here doubt seems to contaminate not only the subject of the thought but the very essence of things themselves. If, instead of commonplace presences, things call attention to themselves as appearances, then what are they? What are these things if, instead of drawing closer by showing us their familiar selves, they move away from us by suggesting that their reality may be only semblance?

In the end, perhaps we have all taken the side of the object. Confronted with the menace that threatens the existence of the world, perhaps we have had to insert a bit of opacity between ourselves and the invisible, an opacity that our rationalist ideology of transparency thought it could dissolve with impunity. Who knows if Le Parti pris des choses (the title of a collection of poems by Francis Ponge) may not be a secret manifesto uniting in a single conspiracy the poet, the artist, and the refusal of things to be inhabited by their concept? Perhaps things themselves have declared war on the dictatorship of the visible.

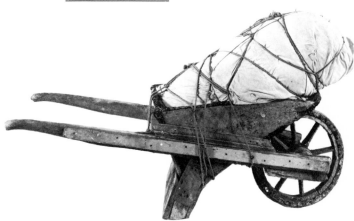

Package on Wheelbarrow, 1963. 35″ × 60″ × 23″. Fabric, rope, wood, and metal. Collection: Museum of Modern Art, New York. (photo: Museum of Modern Art, New York)

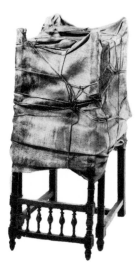

Two Wrapped Chairs, 1961. Wooden chairs, varnish, jute, and rope. 35½″ × 17″ × 18½″. Collection: Laufs Krefeld, Kaiser Wilhelm Museum, Krefeld, West Germany. (photo: S. Korn)

In Christo's work, sign and value are startlingly subverted. Christo does not sell works; he sells the ideas of the work. If we admit that his projects exist only insofar as they are realized, then his oeuvre eludes the normal conditions of commerce. Running Fence is not for sale, or are any of Christo's other projects. In a sense, collectors buy an absense, a void. Of course, this collage is indeed a collage, this pastel a pastel, but if we stop and think for a moment, we see that we have not bought a work but the idea of the work. To be sure, unlike an idea, a drawing is not immaterial; an idea might be exchanged, of course, but it is nonetheless impalpable, invisible, no more tangible than a bit of air, a piece of emptiness. In this sense, it is indistinguishable from the work which can be neither bought nor sold but which is purely a function of the money circulated by the sale of Christo's sketches, his

drawings, his ideas of the work. The buyer is basically in an odd position: what he has bought is taken from him. Although he possesses a drawing that seems no different from other drawings, the act of ownership does not imply that he has the usufruct of this work, a work that is not only unique but simply not there.

In this elegant and almost imperceptible dislocation of the laws of the marketplace, there is something subtly jubilant, something discreetly hostile to the law. In this dislocation, the work—constituted as inalienable referent, as unique, as detached from any intention of giving pleasure—replaces the law, poses as a competitior of its common equivalent. Suddenly, we see why Christo's projects are always self-financing. It is less a question of ethical or political choice than that they do not conform to the logic of the system. Since the final referent is neither salable nor

33

Double Store Front (orange and brite green), Project, 1964–1965. 24″ × 29″. Pencil, wood, charcoal, enamel paint, galvanized metal, plexiglass, fabric, paper. Collection: D. Maysles, New York. (photo: Eeva-Inkeri)

Wrapped Reichstag, Project for Berlin. Collage, 1981, in two parts. 11″ × 28″ and 22″ × 28″. Pencil, fabric, twine, pastel, charcoal, and photograph by W. Volz.

buyable, since the work presents itself as absence, it has the power to create a market in which each sketch or project "functions," not as a piece of merchandise, but as money itself. The difference is that instead of being reinvested in production or hoarded in bank vaults, this money vanishes into a new expenditure that creates no new value. Imagine, for instance, that instead of its gold reserves, Fort Knox concealed an immense vault that opened onto a void; in Christo's enterprise, the money disappears altogether in the pure absence of the ephemeral work.

This subversion of the monetary sign becomes even more uncanny when we consider that one of the most striking effects of Christo's wrappings is their signification as merchandise. Whether building or female body, all these wrapped objects become potential commodities. Unlike Yves Klein's "immaterial purchases," where the point is to buy and sell something that up to then was meant to have no exchange value, Christo's works suggest that the world itself is a function of value. Whatever they may be—wrapped coast, island surrounded by fabric, or gift-wrapped public building—the mere fact of their being wrapped shows the world that the earth and all its continents have become commodities. By metonymy, Wrapped Coast signifies the whole of Australia, now a piece of merchandise in a cosmic marketplace. Similarly, the fact that whole portions of continents are affected by the image-sign of market value (the package, the bundle) destroys the idea of these lands

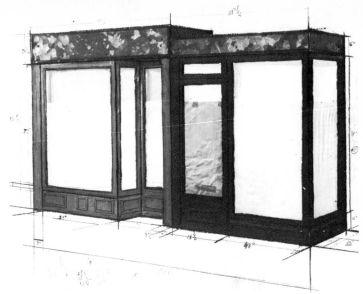

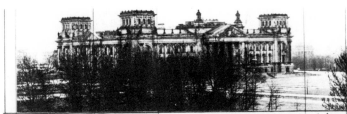

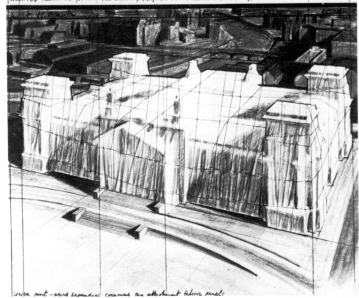

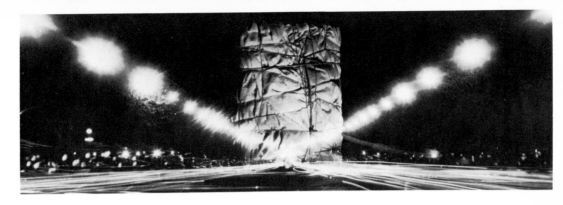

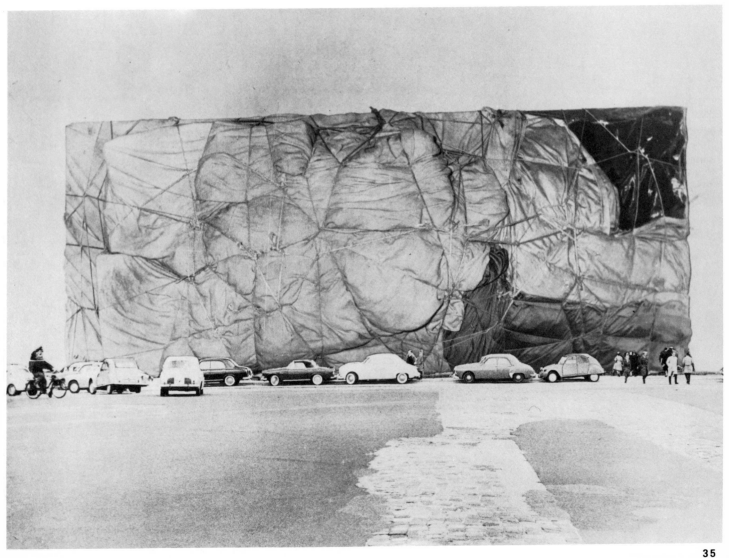

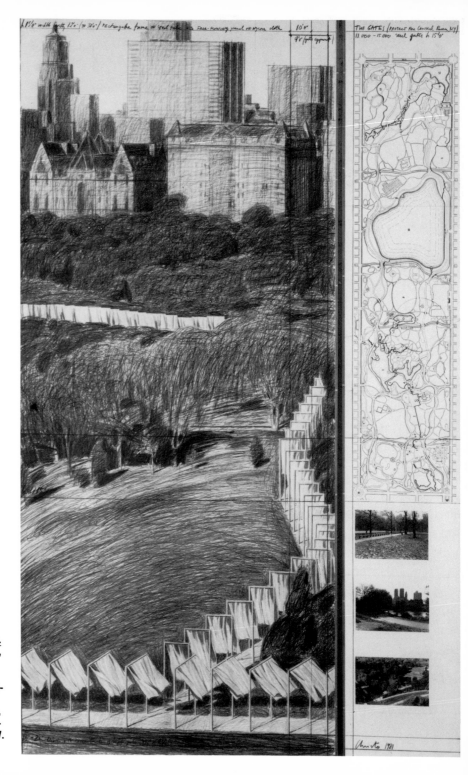

The Gates, Project for Central Park, New York City. Drawing, 1981, in two parts. 96″ × 42″ and 96″ × 15″. Pencil, pastel, charcoal, map, and three photographs by W. Volz.

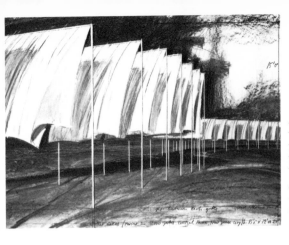

The Gates, Project for Central Park, New York City. Drawing, 1980. 42″ × 65″. Pencil and charcoal. (photo: Eeva-Inkeri)

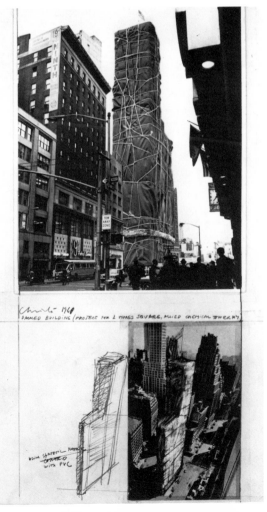

Packed Building, Project for 1 Times Square, Allied Chemical Tower, N.Y. Collage, 1968. 15″ × 10″. Pencil, pastel, photograph by H. Shunk, charcoal, enamel paint, and tape. Collection: Jeanne-Claude Christo.

and islands as immobile. As merchandise, an object is displaceable. Packaged, it is put into circulation. Wrapped, these lands are no longer terres but territoires, objects that we displace and exchange—in sum, the spoils of war.

For Christo's world is a world at war, not only because Running Fence or the Wall on the rue Visconti signifies the partition of the world, not only because the imaginary signification of continents as commodities suggests postwar plunder, but also because these monumental packages declare the threat of war. Who has not seen, perched on trains or parked in the countryside, those long convoys of tanks draped in their fantastic shrouds? Wrapped in their canvas coverings, tanks, cannons, and missiles appear even more menacing than they do naked. Is death less present in the form of a corpse or when it is signified, when it appears as a sheet thrown over a dead body? Camouflaged weapons convey less an unrepresentable horror than a menace which, more than pictures of ruins or mass graves, gives us gooseflesh. A simple sheet thrown over a piece of furniture has more power to dramatize the feeling of menace than a pile of putrefying flesh. For like all things tainted by language, death cannot exist without its signs, nor absence without its signifiers. The wrapping, the veil, the shroud, are the signifiers of death; without them, neither body nor object can be signified as having left the realm of the living. Death is unrepresentable, as is absence. By definition, they are incapable of

being seen; the sign is necessary to signify the existence of that which has ceased to exist.

A splendid example of this paradox is the image of Wrapped Coast, where what is signified is less the picture of a world in mourning for itself than the virtuality, the possibility, of a world about to be removed, a jagged bundle suspended from an invisible crane. Draped in fabric, the world has become a piece of merchandise, accessible to the first dealer who comes along. But if we examine the image carefully (I am thinking particularly of the Shunk-Kender postcard photo), the folds of the rocky coast are imprinted on the fabric; the viewer sees a picture of a fragmented world, barely contained by an excess of ropes, a chaotic mass that must be removed before this parceling contaminates the whole earth. At the very top of the cliff stand two or three silhouettes that seem to be measuring the extent of the disaster. High up on the rock, they gesticulate in vain, for what god would offer even a penny for this unappealing item? Besides, there are cracks all over it. See, look at the angles. The least jolt and the whole thing will fall apart.

42,390 Cubic Feet Package, Project for Minneapolis. Drawing, 1966. 28″ × 22″. Pencil. (photo: Eeva-Inkeri)

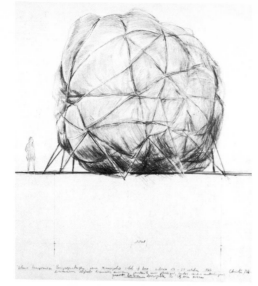

Wrapped Monument to Cristóbal Colón, Project for Barcelona. Drawing, 1977. 65″ × 42″. Pencil, pastel, charcoal. (photo: Eeva-Inkeri)

Project for Monumental "Empaquetage pour Documenta," 1968. Drawing, 1967. 14″ × 10″. Pencil, crayon, charcoal, and architectural paper. Collection: Mr. and Mrs. John Powers, New York. (photo: Shunk-Kender)

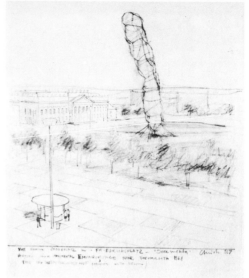

Wrapped Coast, Project for Little Bay, Australia. Collage, 1969. 28″ × 22″. Pencil, fabric, twine, rope, charcoal, crayon, photograph, and architectural paper. (photo: Eeva-Inkeri)

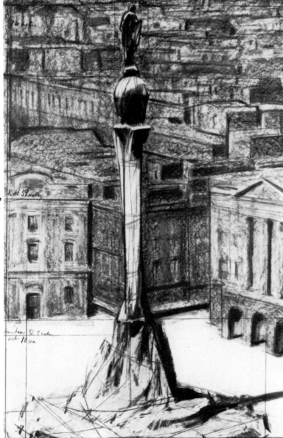

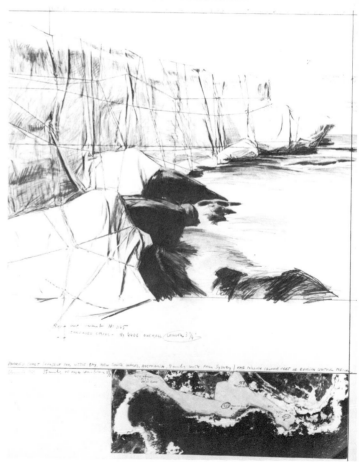

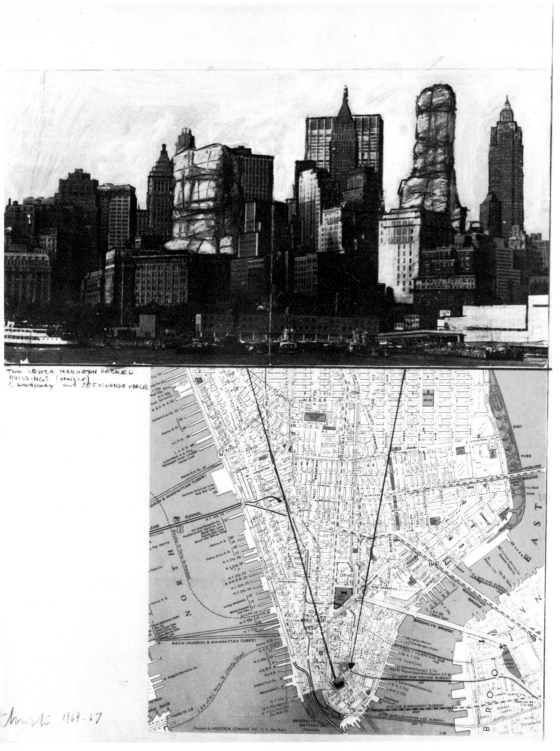

IV
THE BARRICADE ON THE RUE VISCONTI
(1962)

Paris: Wednesday, 27 June 1962—France, Great Britain, and the United States responded yesterday to the Soviet Union's letter of protest, dated June 7, regarding "border incidents." The West Berlin police have received orders to return East German fire should it reach the Western Sector, or should it endanger the lives of any escapees from the East. Le Monde of June 26 declares: "It does not appear that border tensions will ease of their own accord as long as the Communist authorities cannot find a way to stem the flow of refugees through the dike they have erected on the line separating the two Berlins."

Another East-West conflict: tensions between Peking and Formosa, virtually nonexistent for the past two or three years, seem to have been rekindled, if we can judge by the military maneuvers observed in the southern sector of the People's Republic. Although the recapture of mainland China is the number one priority on Chiang Kai-shek's agenda, Formosa cannot possibly see the Kennedy administration abrogating Dulles's refusal, formulated some time ago, to support any invasion attempt. A government press secretary denies that reinforcements have been sent to the Seventh Fleet in the Straits of Formosa.

Sparks fly between Algiers and Paris as construction nears completion on the Pierrelatte plant for separating isotopes, slated to provide explosives for thermonuclear bombs and fuel for atomic submarines. With the referendum for self-determination just four days away, Oran has finally extinguished the 10 million liters of burning oil that exploded last evening after the OAS attack on the reservoirs of British Petroleum. While the funeral of General Ginestet, gunned down in Oran by rebel assassins, takes place at the Invalides, word reaches us that Colonel Dufour has ordered OAS commandos to "put a stop to the acts of destruction" taking place in that city. From the first to the twenty-fifth of June, more than 160,000 Algerian refugees have entered France through Marseilles. Three and a half months after the March cease-fire and the signing of the Evian Accords, the number of violent acts has increased dramatically, hastening the departure of the Algerian French. During this time, arrests and indictments in Paris have continued, notably in the case of Raoul Salan, once again accused of "collaborating with the leaders of armed bands." On the eve of Algerian independence, the Compagnie Française des Pétroles, which has removed its administrative and accounting offices from Algiers to Paris, maintains a guarded optimism about the future development of Saharan oilfields.

In the Middle East, while Golda Meir expresses in the Knesset her desire to see an independent Algeria establish ties with Israel as the "first sign of a new era in Arab-Israeli relations," Anastas Mikoyan has accepted Gamal Abdel Nasser's invitation to Cairo. At the same time, in New York, the Soviet delegate to the United Nations has denounced the amendments proposed by the West to the Afro-Asian resolution calling for the withdrawal of Belgian troops from Ruanda-Urundi. Despite the abstention of the Soviet bloc, the commission has finally adopted the Afro-Asian resolution, after the deletion of all hostile remarks directed at Belgium. In Africa, the president of the Cuban Academy of Sciences addressed the delegates to the antinuclear conference in Accra about the provisions vital to the building of "a happy Latin America." "We wish," he declared, "to push the imperialists into the sea." In this context, a proposition from a committee of the House of Representatives, calling for an end to export licenses destined for "any nation or group of nations which threatens the security of the United States," seems relatively moderate. The committee report specifically mentions the example of a Cambodian hospital financed by Russia and built with American materials, and two radio stations financed by the United States and equipped with Chinese transmitters.

On the same day, word comes from Bangkok that the United States has just granted Thailand a $13 million economic-assistance loan. And to the chapter on East-West relations in Southeast Asia we must add the joint decision of Great Britain and the Soviet Union to hold a Geneva Conference on the subject of Laos. The Foreign Office informs us that both countries have delivered invitations today to the participating governments; the meeting is scheduled to take place on July 2. Meanwhile, the situation at the 17th parallel remains tense. Indian and Canadian members of the International Control Commission have accused North Vietnam of violating the cease-fire by sending arms, ammunition, and personnel into South Vietnam in order to destabilize the Southern sector and to supply the opposition to the Diem regime. (Poland, the third member of the Commission, has refused to sign the report.) The document also accuses the South Vietnamese government of importing war matériel and personnel from the United States. Responding to these accusations, a spokesman for the State Department declared: "The report clearly proves that these decisions have enabled South Vietnam to defend itself against the aggression and subversion organized by the North."

Culture—While France commemorates the tricentennial of the death of Pascal with an exhibition at the Bibliothèque Nationale, and while a show on European religious art opens at the Musée de l'Art Moderne, the debate between the "ancients" and the "moderns" continues in Paris after the publication of Roger Caillois's Esthétique généralisée. Is it plagiarism, or a regression to the Kantian aesthetic? The author argues that beauty has no other model or origin than that which is to be found in nature. In the middle of the twentieth century, such a the-

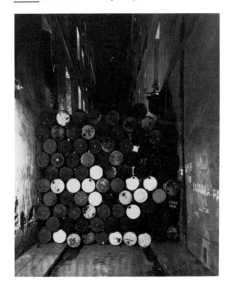

Iron Curtain—Wall of Oil Barrels, 1961–1962. Rue Visconti, Paris, June 27, 1962. (photo: J. D. Lajoux)

sis may indeed be surprising, and we can imagine M. Caillois's irritation at the unintelligible chaos engendered by modern "art" when a painter "paints with blindfolded eyes, or in the shadows."

Miscellaneous—If M. Caillois's readers left the Institut by the rue de Seine exit today, they found yet another cause for disenchantment, for the monstrous traffic jam that par-alyzed the area around the rue Visconti made it somewhat difficult to get to the boulevard Saint-Germain. Traffic was brought to a standstill for several hours by a most untoward event—the construction of a two-story-high barricade stretching across the entire width of the pavement and completely blocking the street that connects the rue de Seine and the rue Bonaparte. A demonstration by militant extremists? The reawakening of seditious forces after the bloody encounter on the rue d'Isly and the assassination in Oran? Or simply an end-of-the-year caper staged by students from the nearby Ecole des Beaux-Arts? It was none of these, but rather the ill-considered gesture of a Bulgarian refugee named Christo Javacheff, seduced since his arrival in Paris by the anarchistic demonstrations of several so-called artists eager for provocation and publicity. Composed of a massive pile of 240 oil drums, and bearing the quite deliberately complex name Iron Curtain—Wall of Oil Barrels, the "work" stood 13 feet high. The artist's entourage fell over one another in their eagerness to explain the highly "symbolic" character of this manifestation, a wall of oil barrels erected "not at all coincidentally" the day after the conflagration that destroyed the oil tanks in the port of Oran. The title of the "work" suggests both a commemoration and a denunciation of the construction of the Berlin Wall last year. But why in Paris? Why oil drums and not cases of caviar or the complete works of Lenin? "Delacroix built barricades, so why not me?" the artist was heard to declare. According to some, it appears that the barricade is as much a part of the Parisian image as the Pantheon or the Arc de Triomphe! Heaven alone knows if one day we may not wind up selling our authenticated cobblestones to American tourists here to pay homage to the land of General Lafayette. . . . In any case, discussion was fast and fu-rious this evening on the boulevard Saint-Germain; some see the barricade as the symbol of a divided France torn by fratricidal conflicts, while others see this traffic obstacle as a finger pointed at the dangers of a "consumer society." The best-advised smile knowingly and recall the extensive exhibit at the Galerie Iris Clert two years ago. A bearded man seated on the shoulders of two young women tried to hoist himself to the top of the barricade. Haranguing the crowd from his improvised perch (every bit as improvised as the wall itself), he shouted to whoever would listen: "I've just come from the Louvre. . . . This is better than Liberty Leading the People!"

The weather in Paris today was moderately warm for the season. The temperature at Le Bourget registered a high of 19 degrees centigrade, in contrast to a 7-degree low during the night of the 26th. Sunny weather throughout France, except for local patches of cloud north of the Loire and in the northeast.

On the stock exchange, the dollar remained stable at 4.9022 to 4.9007, in contrast to yesterday's 4.9007–4.9002. (It remains fixed at 4.89 on the marché parallèle.) On the gold market, trading was slow; transactions totaled 3.56 million new francs, as opposed to 4.75 million on Tuesday. The gold ingot is at 5565, against 5560 yesterday. On the other hand, the Napoleon dropped a bit: 39.70 new francs today, against yesterday's 39.90. On the whole, French securities are holding up well. The Compagnie Française des Pétroles has risen slightly, from 76 to 77.

THE FUGITIVE FROM THE ORIENT EXPRESS

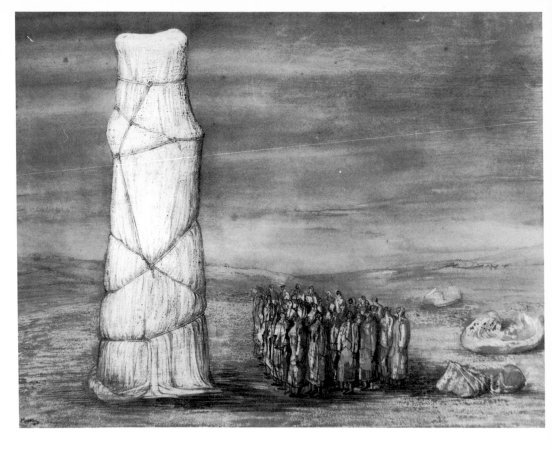

Henry Moore, Crowd Looking at Tied-Up Object, 1942. Pen and ink, chalk, crayon, watercolor. 17″ × 22″. Private collection, England.

Opposite: Wrapped Monument to Victor Emmanuel, Piazza Duomo, Milan, 1970. Woven synthetic fabric and rope. (photo: Shunk-Kender)

Another paradox has been added to the future legend of Christo: the artist whom many of his contemporaries cannot forgive for his resemblance to a capitalist entrepreneur, a position that makes him the ultimate symbol of the clash between Art (canonically virgin) and decadent imperialism (theologically corrupt), owes a great deal to socialist realism! Trained at the Academy of Fine Arts in Sofia and enrolled as an adolescent in the artists' brigades, Christo was exposed from a young age to the techniques of propaganda art. It therefore makes incontestably more sense to seek the origins of his work in those early years of training than in the problematical "influence" of Duchamp's Sculpture de voyage or Man Ray's wrapped sewing machine.

In the first place, Christo's drawing clearly shows its academic origin. It is not hard to imagine that had he been trained in a Western school, his style would have an ampler, more supple movement, a more non finito quality; instead of drawings that resemble architectural blueprints, we might have the spirited sketches of a young virtuoso eager to show off his casualness. Just as Christo's works resemble engineering plans, with their deliberate and avowed fascination with financial, technical, economic, and social detail (environmental-impact reports, studies of effects on various populations), so do his preliminary drawings reflect a formal kinship with the art of the monumental—in construction and architecture—rather than with painting. The weightier the drawing, the more technical, with its notes, its anatomies, its inscriptions, and the more each model, collage, and drawing belongs to the realm of architectural fiction. The obvious seductiveness of these preliminary sketches owes a great deal to the discrepancy between the disproportionate, gratuitous, outrageous character of

42

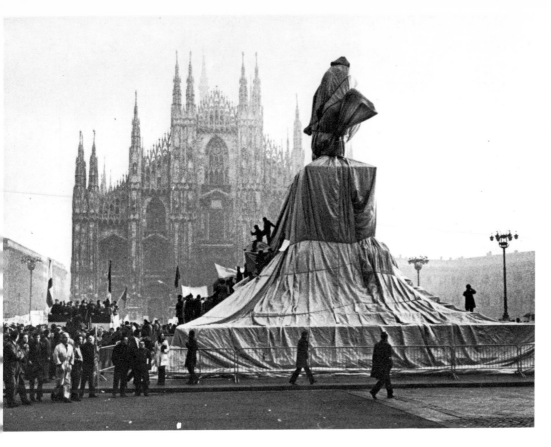

fantastic, but in making the fantastic more banal, the real is suddenly made fiction.

Christo's academic training, however, is not in itself responsible for his later reversal of the basics. Socialist Realism cannot be defined only in terms of an apprenticeship in painting, but also by the way it engages reality, by its capacity as an instrument of propaganda for a given ideology. Propaganda art involves direct intervention in the world as we customarily perceive it, a kind of "surgical operation" on the landscape so that it conforms to the image of a new world, a prosperous world commensurate with the promise of happiness heralded by the new messianism. Thus Werner Spies, in his introduction to Running Fence, notes the results when, from 1952 to 1955, the students from the Sofia Fine Arts Academy had to donate their weekends to the state, traveling to the countryside every week for their apprenticeship in socialist realism:

Their job was to spruce up the landscape along the section of the Orient Express route which passed through Bulgaria, for the benefit of travelers from capitalist countries. During the Cold War this was the only train from the West out of whose windows travelers could watch a communist country pass in review. Farm walls facing the railway were given a welcoming coat of paint—Potemkin villages, revolutionary idylls. The work forces sent out by the Academy in Sofia had the additional task of dramatizing and glorifying the work of the peas-

the object and the academism of its representation. Christo's academic style—the presentation of absurd subjects with architectural verisimilitude—gives his drawings an uncanny effect (the germ of seduction), the result of a collision between realism and the fantastic. Where a hazier, more impressionistic, and more phantasmal drawing would be consistent with the fabulous reality of the work, it would, paradoxically, completely fail to evoke that uncanniness which comes from establishing the greatest possible distance between the realism of the representation and the unreality of the object.

This distance belies the influence of Western artists like Duchamp and Man Ray on Christo's work. Even the famous Henry Moore watercolor of a crowd looking at a packaged obelisk (Crowd Looking at Tied-up Object) cannot really be considered a forerunner of Christo's monumental packages, for if Moore's idea belongs in the domain of the fantastic, so does his style. When the work itself is similar in form to the phantasmal, it cannot provoke that disruptive charge which results from the discrepancy between the imaginary status of the object and the realism of the form. Paradoxically, the academism of

the drawing in no way detracts from the avant-garde character of the project; on the contrary, it is a necessary condition of it. The more the academism of the representation incorporates the phantasmal content of the object into reality, the more reality is upset, destabilized, placed in doubt by that object. The fantastic in itself does not disrupt reality, but rather its realistic representation. And the more realistically it is presented, the more it infects reality with a "disturbing uncanniness," the logical correlative of the "strangely familiar." The real is neither heightened nor rendered more alien by this addition of the

ants in the collective farms. Their activities were set out in the most effective way, as if in a shop window: "We positioned the machines to look dynamic. We told the peasants they should set this threshing machine clearly outlined on a little hill—as if on a pedestal. When pipes were delivered for a water main that was to be built near the river Maritsa, we stacked them in artistic piles."

A singular interpretation of Feuerbach's Eleventh Thesis inscribed on the façade of Humboldt University in East Berlin: "We must no longer interpret the world, but change it." Since the world needs to be redesigned, the contributions of artists are not to be ignored; as masters of illusion, they will be assigned to decor, thus getting a head start on the transformation of the world by making it conform, at least visually, to the foreign traveler's image of socialist happiness. The trompe-l'oeil libraries and the paintings on the vaults of churches in the bourgeois world pale in comparison with this generalized trompe l'oeil that presents what ought to be but is not. Here the art of illusion is pressed into the service, not of an aesthetic beauty, but of beauty as an index of prosperity and wealth. Objects are exhibited, not for what they are, but for what they signify. This is a Platonic conception of art (without the moralism), which puts aesthetic know-how at the disposal of imposture. "Activities were displayed with great style, as if in a shop window," Christo has remarked, a comment that takes on a certain

importance given his later Showcases and Store Fronts. In the eyes of the traveler, the world speeding past his window is itself a window, one that pretends to be not a window but reality itself. It is not the traveler that observes the landscape, but the landscape that observes him; socialist prosperity and happiness now turn their reproachful stares on him. Here the "superstructure" inspires guilt; dressed up for a parade, the landscape sermonizes the Orient Express traveler on his ignorance of socialist reality. Later, when Christo reaches the West, he will wrap the insides of store windows; instead of displaying the nonexistent, he will mask the giant eye that follows the window-shopper: "Are you as well dressed as I am?" it asks. "Do you have your washing machine? Why don't you take a good look at yourself? I who look at you know full well that you are not what you seem. Go on, look at yourself! It's obvious you don't look real. So dress yourself up!" As one who felt himself observed not by the painted housefronts of farms but by their back yards, Christo here exposes the extent to which objects observe us. Who is better able than he to know that the harvester up there on the hillside, the tractor parked next to the stack of pipes, the cows and threshing machines, the posts and sheep were looking at the traveler, ordering him to repent for misinterpreting the happy landscape of socialism? Christo watched them speed by, these dupes of illusion; how could he not have felt himself judged by all this semblance?

Retracing his steps, secretly fleeing this theater of illusion, what does he discover? A world peopled with merchandise he has to paint in trompe l'oeil for the benefit of passing tourists. A puritanical reflex: he drapes the merchandise, covers it up. It is simply too much. The illusion must be masked, not to lead tourists from the East (there aren't any) to believe there is nothing but a void behind these wrappings, but because the illusion itself must be concealed. And what does he drape in this veil of modesty, a reflection of his shame as a maker of illusion? He drapes museums, pieces of merchandise, women's bodies, everything that signifies opulence and luxury, everything that is nonexistent on the other side of the frontier. It is not exactly that there are no women in socialist countries, but they do not exist as bodies, as objects to be looked at. Of course, there is that little girl over there, perched on the tractor alongside the road . . . but her long blond hair and her skirt pulled down carefully over her knees clearly suggest that there are only virgins in the empire of the Little Father of the People.

A puritanical gesture—put make-believe on hold awhile, along with the bulimia of a long-frustrated child; if that's the way it is, let's wrap everything. Then there won't be anything left but merchandise; the rest is nothing. But is there really nothing left? How about some oil drums? Now here, at least, we've got something to work with. No point in piling them up all along the tracks to create some sort of illusion when we

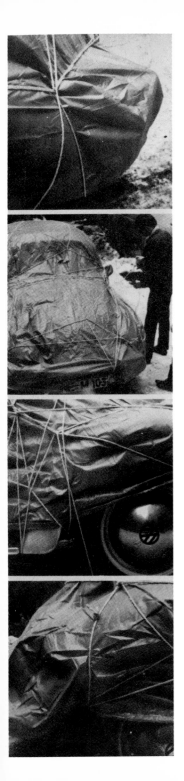

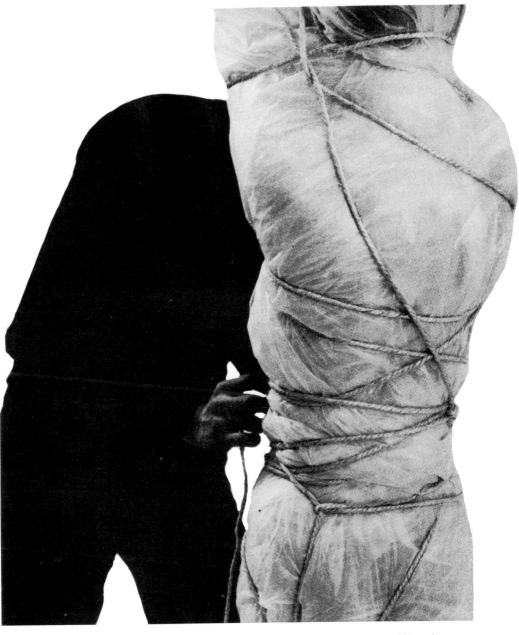

Wrapped
Volkswagen,
Düsseldorf,
1963. (photo:
Charles Wilp)

Wrapping a
Woman, Düs-
seldorf, 1963.
(photo: Charles
Wilp)

can make piles for <u>real</u>. Textbooks on political economy don't know the half of it when they start analyzing merchandise and surplus goods; there is so much stuff that stacking pipes to create a thing of beauty is no longer a state duty but an expenditure tackled in play. Beauty doesn't have to be the mercenary in an image of productivity. No longer a fallacious index of prosperity, beauty can now be its waste product.

Yet Christo's aesthetic differs significantly from the one he encountered upon his arrival in the West. During the 1960s, the New Realists with their practice of reclaiming industrial waste—Tinguely's scrap metal, Arman's accumulations—reigned supreme in Paris. Their point was to organize the refuse of an industrialized society; as a way of contesting the society of consumption that nourished it, art took upon itself the job of converting this waste. Christo's aesthetic, on the other hand, is in no way denunciatory. Ironic, of course, but its aim is not to condemn the accumulation of merchandise as the sole objective of the capitalist system. Instead, it suggests that the entire world is a function of market value, not only traditional consumer goods but <u>everything</u>—women, beaches, oceans, and, most important, the landscape. That the countryside is a value was not something Christo learned when he arrived in the West. This was something he had known for a long time. He himself had operated on it, making it the index of a prosperous economy, slipping counterfeit money, as it were, past the eyes of tourists expecting to cross an impoverished country.

The rural agitprop lesson, however, goes beyond simply arranging the landscape to signify its contamination by exchange value. The lesson also entails making the industrial object intervene in nature itself. More precisely, it suggests that the intrusion of an alien body into the landscape does not necessarily obscure its beauty but, on the contrary, can be integrated into it without <u>denaturing</u> it. In other words, these years of apprenticeship gave Christo experience in a technique that would culminate in <u>Valley Curtain</u> and <u>Running Fence</u>—a break with the Kantian aesthetic through the affirmation that objects extraneous to nature can be a plus value, that they can in fact add to the beauty of nature.

In any case, we must remember that if the traveler on the Orient Express saw a landscape that had been manipulated by brigades of artists, Christo himself had to work with a space in which <u>the train itself was part of the landscape</u>, a <u>frontier</u> between East and West, a moving, shifting boundary as well as a dividing line. On the one hand, the train symbolizes and concretizes the <u>crossing</u> of the frontier, but on the other hand, the <u>tracks</u> are themselves the frontier in the sense that here and now, on the earth, they are the only "line" on which the West may "circulate." After all, at the moment the train is passing, everyone is free to imagine that behind it, beyond the tracks, another country begins. A train is all that is needed for the disguised landscape to become in itself

Running Fence, Sonoma and Marin Counties, California, 1972–1976. (photo: G. Gorgoni)

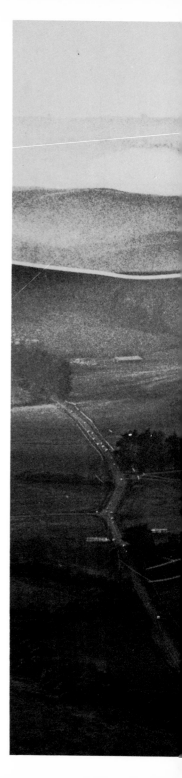

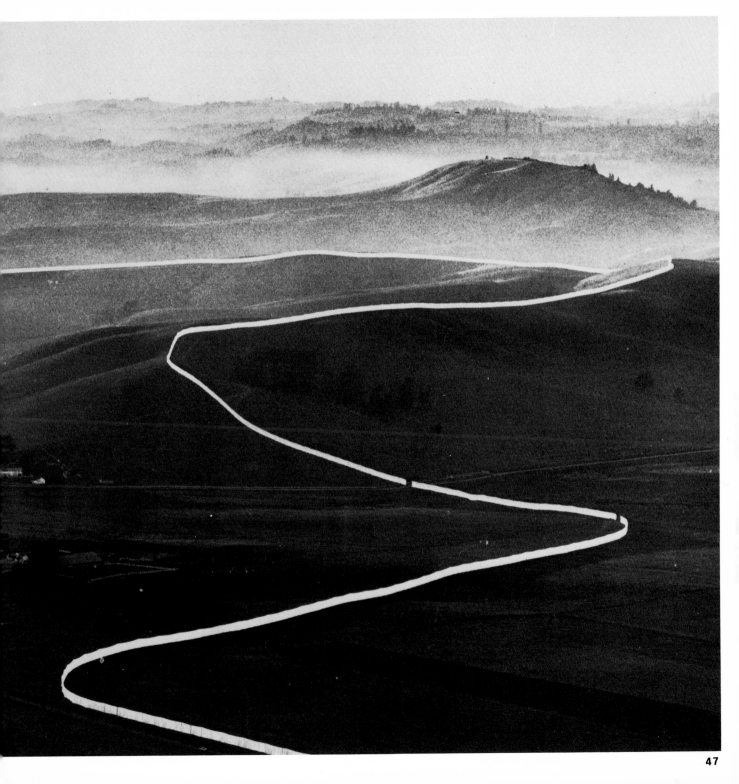

the entire world. This is doubtless why one of Christo's most spectacular projects shows so clearly that a frontier is not static, but rather a <u>line</u> that <u>keeps changing places</u>. For if <u>Running Fence</u> is a parodic copy of the Berlin Wall, it is also the phantom of the Orient Express. It runs through the countryside; it weaves between the valleys like a train; and it has a direction. Like the fugitive the train kept trying to glimpse, it moves from East to West. He who adjusts the countryside for the benefit of travelers is himself inevitably observed by that moving frontier. He who <u>knows</u> that the landscape is a fake, he who does not see the rest of the world beyond the train, he is himself watched by the eyes he lies to, by the eyes for whom he disguises the truth of the landscape.

In fact, this is a singular—although widespread—strategy: to conceal the truth, it is not necessary to hide it, but to expose it. The lie is created, not by a mask or wrapping, but by an excess of illusion. Because the lie has a structural capacity to conceal by declaring what is truer than the true, and because the truth has an innate tendency to flee into appearance, Christo's work cannot be reduced to a sociological interpretation wherein the packaging signifies merchandise. For the renegade, there is an equivalency between flight from a country where his artistic technique consisted of exhibiting in order to conceal, and its opposite—a systematic submission to the art of concealing, or wrapping. Is this technique allegorical? Is it a simple reversal where the

artist switches from the obligation to exhibit something in order to conceal it, to a position where he feels obliged to conceal something in order to exhibit? If so, then what is the object of this exhibition?

The answer varies, depending on the mode of packaging and on the periods when it is possible to hypothesize about the function of the veil, or wrapping, as a <u>displacement</u>. It is not necessarily the same thing when Christo wraps a monument in an ephemeral fabric, and when he wraps an object for an indeterminate but definitive and uninter-

the world, and are torn apart at every frontier. In the eyes of the police, more than anyone else, there is obviously something there, something other than what is supposedly there, something other than the package itself. To be sure, there is <u>nothing</u>, and the fetishistic expectations of these official vandals can only be disappointed. In this case, however, the object is not packaged in order to be unwrapped. Indeed, the condition of <u>rape</u> is necessary to disappoint the expectation of something psychoanalysts would doubtless call the "maternal phallus."

<u>Running Fence.</u> (photo: W. Volz)

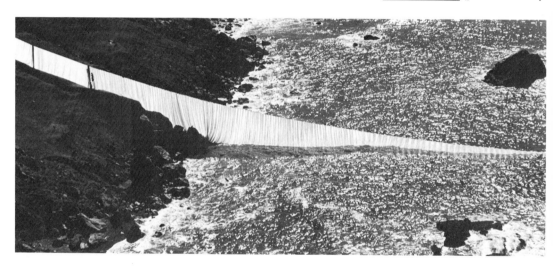

rupted length of time. In both cases, of course, the wrapping raises the same question, one inherent in and essential to the function of the fabric: "What can possibly be behind it?" The wrapping compels the viewer's consciousness to an imagined certainty that there <u>must</u> be something. The proof is that these wrapped objects from Christo's early period arouse suspicion at every custom in

In any case, the end result of wrapping <u>is not</u> unwrapping, or revelation. Its function is not to disappoint expectations but to suspend them, to keep the question perpetually open. When the museum-goer looks at a package of fabric on a table (<u>Package on Table</u>, Stedelijk Museum, 1963), nothing allows him to say that behind this wrapping there is in fact nothing—except the wrapping, in-

finitely folded over upon itself. In this case, the wrapping reinforces the belief; it presents itself as a Mystery whose rite has been suspended since the aim is not revelation. Here the veil, or wrapping, still seems to belong to the tradition of painting; without a tear or rip, it will not of itself reveal the absence it encloses. At this point, Christo is still not situated on the frontier of his

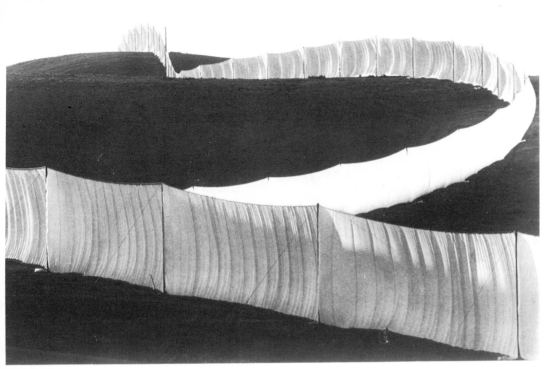

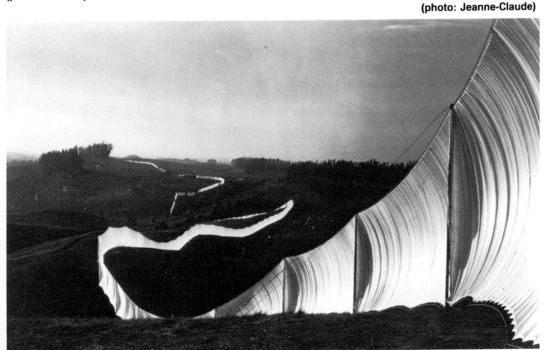

name; he does not wrap objects with a shroud in order to undress them, but rather creates a <u>mummy-phantasm</u> that maintains the mystery of what is behind these strips of cloth and that perpetuates, through the belief in the "maternal phallus," our unconscious knowledge of eternity.

Something changes with the wrapped nudes and particularly the monumental packages of Christo's "second period," for here the veiling (as perpetual shroud) becomes <u>ritual</u>. It is placed for a moment over things which, in the end, regain their full integrity. The menace has lasted for only an instant, and the unwrapping will prove that there is nothing more to see than what was already visible. On the other hand, the unwrapping will not exclude the possibility that something "might have" happened, or that something did "perhaps" happen, something invisible and forever unrevealed. It is as if, between the bands of cloth placed <u>ad aeternam</u> around the object and the wrappings put in place and then removed, there has been a passage from pagan mystery to a forgotten variety of Christian ritual. If something remains, it is the veil itself, which persists only as a memory, an inaccessible fetish unveiling the fact that once upon a time something happened—something forever lost, an object of nostalgia that bears no relation to anything except perhaps the phantasmatic repetition of that unique moment.

VI
THE VEIL

In the end, why were the popes who dressed the naked bodies on the Sistine Chapel in veils and pieces of clothing necessarily wrong? Of what exactly were they guilty? Defacing the primitive purity of the work? Adulterating the virginity of painting? Violating the corporeal integrity of the artist? We have known for some time now that the ideal of <u>transparency</u> is shared by all utopias, and thus, that utopias are totalitarian. Rousseau's nature, Bentham's all-seeing eye, Fourier's universal harmony are as responsible for the world of concentration camps as the <u>Essay on the Inequality of Human Races</u> or the <u>April Theses</u>. All the more curious, then, that the gigantic accumulation of flesh into which the twentieth century has plunged, body and soul, has in no way destroyed this ideal of total visibility, despite the fact that when it comes to illuminating History, it has shown that we only succeed in illuminating hierarchies. Transparency in social relations, transparency in communication, transparency in love relationships through the popular practice of reciprocal confession, transparency in clothing, in living quarters, transparency in death itself (transmitted in full color from the four corners of the globe), glass walls, open-air pipes and passageways—in its accumulation of cadavers, our century practices a worldwide nudity.

Even more curious is the fact that art has replaced politics. From Italian Futurism to New Realism, from the <u>Città Nuova</u> to the Architecture of Air—which places the Kleinian citizen in an imme-

Wrapped Floor, Museum of Contemporary Art, Chicago, 1969. 2,800 square feet of dropcloth, and rope.

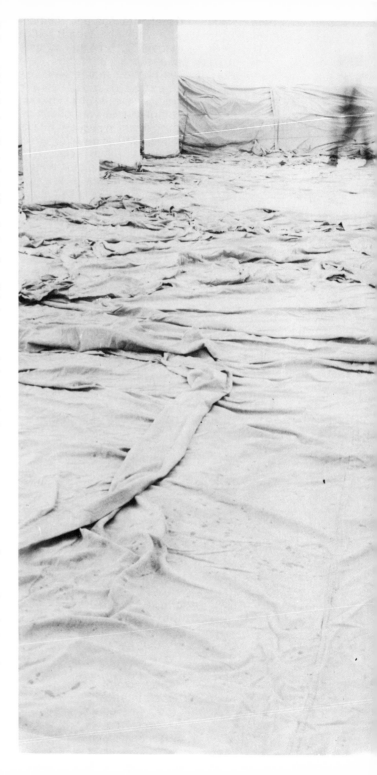

diately transparent relationship with the world, which renders both body and consciousness translucid in the eye of the beholder—art has failed to appreciate fully the predictive value of its utopias. Profiting from a politics of reconstruction necessitated by widespread massacre, architecture actually accelerates the rhythm of the propagation of lights; it raises glass blockhouses on the outskirts of cities which capture the jumble of streets and sky, man and the cosmos, in the play of their mirrors.

As troubling as it is to realize that utopias, in principle meant for the good of the people, systematically turn into their opposite, it is nonetheless comforting to note that techniques with diametrically opposite effects can come from a single group of similar ideas. Both Air Architecture and the concept of the Void are constitutive elements in the discourse surrounding the birth of Christo's oeuvre. For his constructions, at the confluence of architecture and Land-Art, are also utopias. Singular utopias, however, since they do not include the fantasy of world transformation. In its desire to reshape the world according to a preexisting image, a utopia invariably reinforces the same norms it has been created to condemn or destroy. The ludic quality of Christo's work, its ephemeral character as device, the sense of the imaginary it retains even as it is realized, all derive from the fact that it is not a vector for the potential transformation of the world. Indeed, the effects of this rupture with the fantasy of universal transparency come from

the materials used in the work (the synthetic veils) and from their function as wrapping.

Where Klein's Architecture of Air was the vector for a lethal omnivisibility, Christo's shrouds, instead of accelerating the transparency of people and things, restore to the world a sense of mystery. What he sees forces the viewer to ask what is going on underneath those draperies—a mystery? a rite? Why not a primal scene? But it does not move. It does not breathe. A cadaver? Far from forcing the spectator to mourn the death of the world, the shroud signifies, visually, that all things will eventually die. The stone or wall that protects us from the danger of encountering the image of our mortality is itself depicted as inhabited, in a manner of speaking, by a consciousness of death. Once objects are depicted as capable of dying, it is as if they were able to speak. A consciousness of time inhabits the shroud; this picture that is silence forces speech. It compels people to talk of it; it summons all of us ordinary mortals to ask one another, "What could possibly be hidden under there?" Of course, by virtue of its mere presence, any veil invites its removal, for the function of all taboos lies in their potential transgression. Why, then, do we always attach a negative valence to wrappings, to disguises, to things that deceive? If a veil reveals what we must not see, thus making the reality of sex and death bearable, then its displacement onto other objects—a monument in a state of erection, for instance—carries a discursive function that works back-

ward from one lethal and transparent body to the next. It does not force the guilty to pour out their souls, as do the orgasmic imperatives of the Beaubourg Museum. Instead, the wrapping is content to make a serene suggestion: namely, that even when all veils are lifted, no one will have finished his confession.

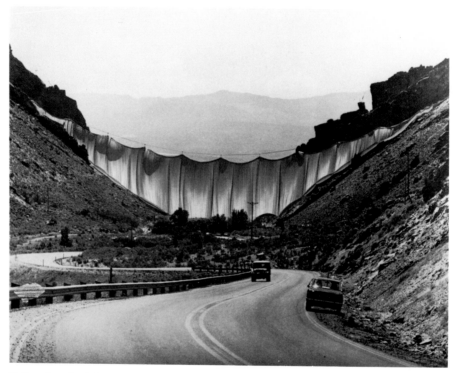

Valley Curtain. (photo: Shunk-Kender)

A curtain blocks the valley. Are they erecting a frontier? An impassable boundary that will force drivers to turn around and go back? The limits of the world defined once and for all, a roadblock commensurate with the human effort to push back the boundaries of the known world as far as possible and thus to build new roads, new bridges?

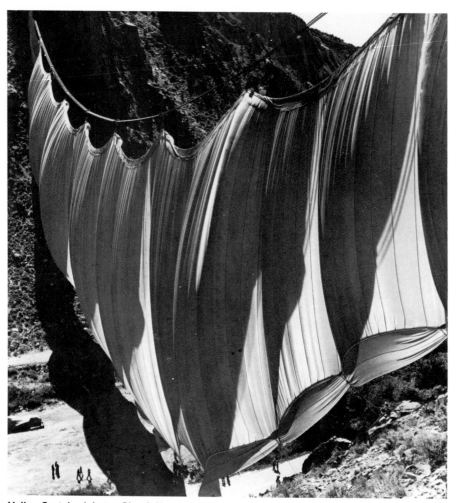

Valley Curtain. (photo: Shunk-Kender)

It is the priests alone who define the limits of the known world. And the warriors who build walls around conquered territories. Is this curtain defending a world beyond? Is it a frontier drawn by a new kind of conqueror?

Suspended from hillsides, it is not a wall but a veil. Enlarged to the dimensions of a gigantic spinnaker, it needs only a puff of wind and the air will fill it. . . . The earth is now an old tub of a boat; the world readies itself for takeoff.

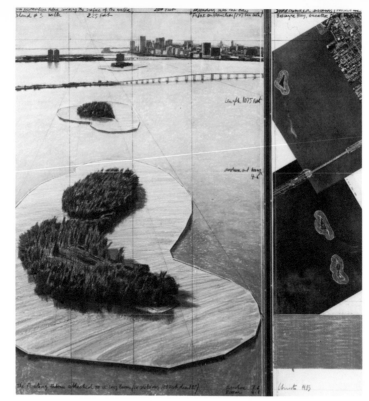

Surrounded Islands, Project for Biscayne Bay, Greater Miami, Florida. Drawing, 1983, in two parts. 65" × 42" and 65" × 15". Pencil, pastel, charcoal, crayon, enamel paint, fabric sample, and photographs. Private collection, Colorado. (photo: Eeva-Inkeri)

What are the contemporaries of Christo's water lilies? Monet's Les Nymphéas and Cézanne's Les Baigneuses are doubtless not so much the precursers of this abstraction as they are subjective apprehensions of space and time, immediately preceding the reorganization of Newtonian space by Proust and Freud with their discoveries of the way memory and language work. Christo's Miami water lilies belong to a universe where the human eye leaves the world behind. Few of the sketches show the islands on a human scale; most are drawn from a supraterrestrial point, a bird's-eye view, so to speak, where the spectator sees these bits of earth and their polyethylene buoys as if from an airplane.

An eccentric with quite a fertile imagination dressed ten small islands in Biscayne Bay in a sort of Mae West! Was he afraid the earth would drown, or was he trying to raise part of it from its pedestal? The man who invented a dirigible with the earth as its cockpit is perhaps only restating in different terms what the discourses of science and war keep repeating as the twentieth century ends: the time has come to leave this sinking ship. The era of interstellar voyages has consigned the planet to an archive of closed files. The earth is no longer a badly wrapped bundle (Wrapped Coast, Little Bay, 1969) but an errant ship kept afloat by a belt of buoys.

Nature has stopped looking like itself. When the object is a landscape incongruously encircled by pink nylon, it no longer forms a part of known space. By its unfamiliarity, it perverts our space, like a flying saucer that has assumed the shape of an oblong water lily mysteriously colored green and pink. Where does it come from? What is the origin of this object that surrounds our familiar landscape and renders it unrecognizable, even to itself? When the landscape cannot integrate things that come from outside it, then it has undergone a topological revolution. When it no longer absorbs objects the eye perceives as foreign, then its verisimilitude is thrown into question and the landscape itself becomes an alien object.

The Surrounded Islands say to us: "Footprints have been left upon the earth," an apt motto for the phantasm of a civilization marked by the "last

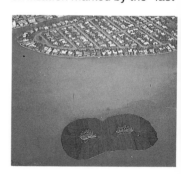

(photo: Jeanne-Claude)

man" syndrome. In this recently defined clinical condition, the footprint is a symptom, but its significance is far from univocal. It refers both to the anguished appeal of the invader marking the earth with his footstep, and to the footprint of man himself, frozen in the image of the conqueror who kicks away the earth for a foothold in the stars. The Miami islands do

not look like something we see before us, but like something we have left behind. Seen in three-quarter profile, they suggest the head of a traveler tossing a last look over his shoulder at the earth he has just left.

There is no such thing as a univocal work of art. Were it pure message, it would dissolve into pure conjecture about data and event, thus becoming a satellite of the first ideology to happen along. Christo's works reveal both a fascination with engulfment as well as a denunciation of our civilization's self-destructive impulses. They parody the discourses of science and war, but who can tell whether or not they themselves participate in this discourse? Their strangeness makes them vectors of an apocalyptic message, but their beauty puts them on the side of laughter, derision, and absence—places where the social fabric ceases to be obsessed with its own expansion or reproduction, and discovers the pagan pleasures of excess and play. Of all Christo's projects, <u>Surrounded Islands</u> is incontestably the <u>rosiest</u>, not only because of the color encircling the green of the vegetation, but because there is no single interpretation of an act that wraps close to a dozen Florida islands in something that might be a life jacket, the white of an egg, a pair of overalls, an artificial beach, a rubbery fetish, a gigantic party cake, a flower, a technological innovation for the displacement of currents or the capture of hydraulic energy, an alluvial deposit composed of waste products from a lipstick factory (a pink tide), a vastly enlarged soft watch, a dock-

ing platform, a monstrous bonbon for Alice in Wonderland, or a Victorian present from God to his children in the form of a little pink panty for the earth to wear.

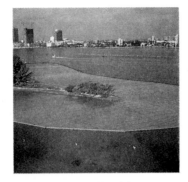

(photo: Jeanne-Claude)

An island is an object of desire. Detached from the main body of the world, it has the fragility, the transience, the changeability, the instability of desire. For in our imagination, an island is something that floats. Who can swear in good faith to having always seen this morsel of land anchored to the pedestal of the earth? Of all the sensory impressions provoked by <u>Surrounded Islands</u>, the least debatable is that the fabric has caused the earth to rise up and be transformed into a sort of tropical iceberg, complete with vegetation and the colors of trees and sand. The fabric reduces the island to a flat surface without depth or bottom. In our imagination, it erases the invisible anchor that attaches this bit of land to its permanent place. Like the landscape that no longer looks like itself, the island is severed from its definition (an expanse of terra firma risen from the sea) and returned to the realm of the imagination, where it becomes a bit of

floating earth. Its immobility becomes virtually a fiction; we see that it can sink, that it can come unstuck. And we sense that it can move about on the surface of the water, that its immobility is purely provisional, accidental.

An island is a blob of clay dropped on the sea, a blob of clay that floats. This is what children believe and legends sometimes say. It is a foreign object from a puzzling elsewhere, with two axes of perception—the vertical (an abandoned or conquered piece of land, a footprint), and the horizontal (a piece of floating territory detached from the earth)—that intersect, forcing us to see that point where origin and end coincide. An apocalyptic verticality—the presentiment of disaster. An imaginary horizontal—nostalgia for a mythical past. On the one hand, a Mae West holding up a world on the verge of drowning; on the

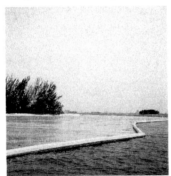

(photo: Jeanne-Claude)

other hand, a rose-colored buoy that restores our ludic perception of the world—floating islands that can be played with like marbles. But the child rolling the ball is a divine child, and even if we can imagine that the earth is not a sacrifice to the dark gods of space, since it floats

it is still within easy reach of the giant. The very immensity of this floating earth makes the child playing with it a mythical god.

If the earth is not on the verge of disaster, it is only because it continues to repeat its mythical origin. Each island is a lump of primal mud floating on the ocean, an oil slick painted pink to restore to us nostalgia of chil-

(photo: Jeanne-Claude)

dish beliefs, so undifferentiated from the mythic genesis of humankind. Only now can the eye return to that place of origin where it unconsciously reinvents a cosmogony known to all but unknown to each of us individually. It is like the Japanese legend: "After Izanami and Izanagi had received a bejeweled lance from their ancestor-gods, they walked out on the celestial bridge and plunged the miraculous lance into the magma which was then the universe. As they probed, they discovered an ocean. A drop of mud fell from the lance when they raised it from the magma, and the first island was formed. And it received the name Onogoro-Jima, or spontateously formed island."

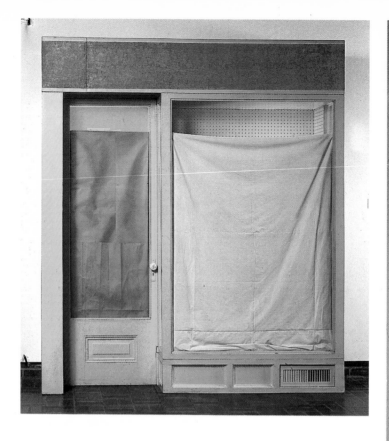

Store Front (Yellow), 1964–1965. 98″ × 88¼″ × 16″. Wood, plexiglass, fabric, paper, galvanized metal, pegboard, and electric light. Collection: Mr. and Mrs. Horace H. Solomon, New York City.

Corridor Store Front, 1967. Aluminum, wood, plexiglass, and electric light. 1,513 square feet. Façade: 12′ × 12′. Collection: the artist. (photo: F. Boesch)

If the act of wrapping a monument (Wrapped Kunsthalle, Bern, 1968; Packed Museum of Contemporary Art, Chicago, 1969) or an air column (Air Package, 1966) does not seem to pose a problem in terms of the object wrapped, it is an entirely different question when we consider other works, less well known perhaps because less spectacular, like the Showcases or Store Fronts realized during the years 1962–1963 and 1963–1967, respectively. The principle of Showcases is simple: rectangular glass boxes, lit by neon, and "wrapped from the inside" by a fabric that covers each internal side of the glass. We sense, or think we sense

(since one persistent story claims that Christo "rejoined" the New Realists in 1962), that the concept behind Showcases owes something to Klein's famous exhibition Le Vide (The Void). Yet despite the formal similarities between the two expositions, it would be rather adventuresome to claim that both shared the same object. What is Klein really doing when he stakes out a space and "signs" it as a void, or when, during the same period, he sells rights to this immaterial zone? Just as he takes possession, imaginatively, of the totality of world events in his Journal, so does he exhibit an "object" which he severs from its claim that it transcends any possi-

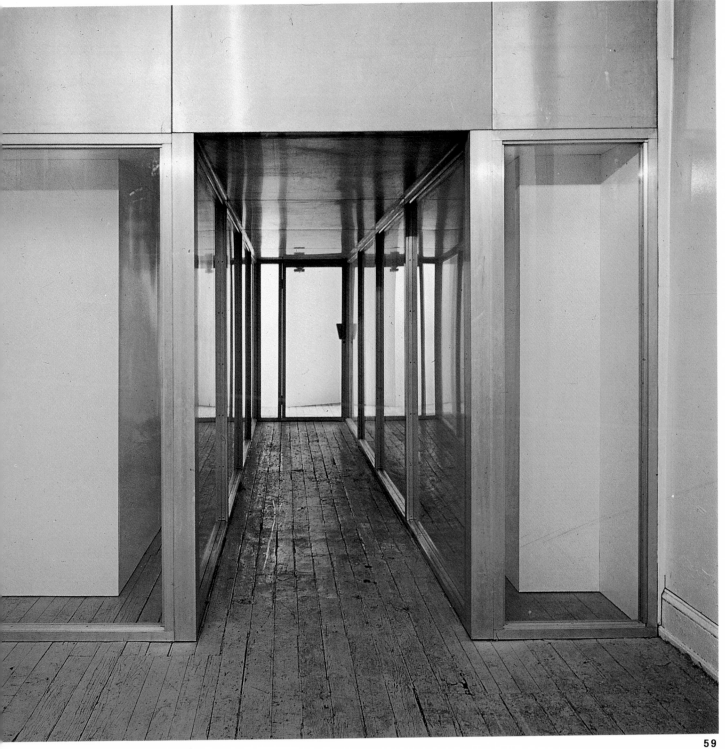

ble appropriation. By the simple affirmation of the omnipotence of language, he playfully reveals that the void itself is an exposable object. Like all other things with an exchange value, it is salable, even subject to bargain prices. In a word, he takes possesion of the void.

If Christo's packages also come to signify the potential exchange value of objects that hitherto transcended the laws of the marketplace, his process nonetheless is markedly different. Just what is he wrapping in these Showcases and Store Fronts? Some air? A void? A space? We know that the game of Go shares with both topology and Chinese warfare the possibility of encirclement from the inside. And we know that in topology, a fence around a square surrounds not only interior but also exterior space. What is Christo doing when he wraps the inside of a show window? Is he taking possession of a space delimited by the parallelepiped of the window, or is he encircling "from the inside" a space outside the window? It seems that a Christo package crates a void around itself. The surrounding space is appropriated, irradiated in all its parts by the ghostliness of the wrapped object. It seems, too, that what appears only visually in Christo's other packages is logically constructed in the wrapped interiors of these windows. In relation to future endeavors, the Showcases are rather like "logical concretizations," devices that define the relationship between wrapped "content" and the surrounding space. When emptied of everything except the fabric or paper that screens each interior side of the glass,

Corridor Store Front, Back Room, 1967. As installed at the Stuttgart Kunstverein, 1974. (photo: W. Volz)

what then is the window displaying? "Anatomically" speaking, it is like a glove turned inside out. The inside becomes the outside; the objects that ordinarily occupy the space in a store window are "transposed," transubstantiated in the eyes of the spectators who are henceforth prisoners of the window that looks at them. In fact, we might even say that the crowd of spectators are themselves wrapped objects. At the least, the gaze of each passerby is in a paradoxical position; since he cannot see "from the inside" what is happening in the window, he perceives the space in which he moves as itself surrounded by the glass. This device in no way suggests that the wrapped space has been acquired, for it does not belong to the artist. It is neither a "piece of property" nor a "piece of knowledge," which, by a linguistic act, proposes the void as the "content" of his exposition.

What is really in these show windows and store fronts of Christo's? Well, nothing. A vague mixture of nitrogen and oxygen perhaps, but the act of exposition does not even give it the signification of "air" (much less "void"). There is nothing, for the good reason that the street has become the content of the window. The marketplace is not inside but outside; my gaze has become an object covered by what is now occupying the space I as a spectator normally occupy, the space on "the other side" of the window. But there's nothing there! Perhaps not, but since it is being exhibited, we'll have to believe that my gaze can make nothingness very appetizing.

X
THE MASTABA
OF ABU DHABI
(PROJECT)

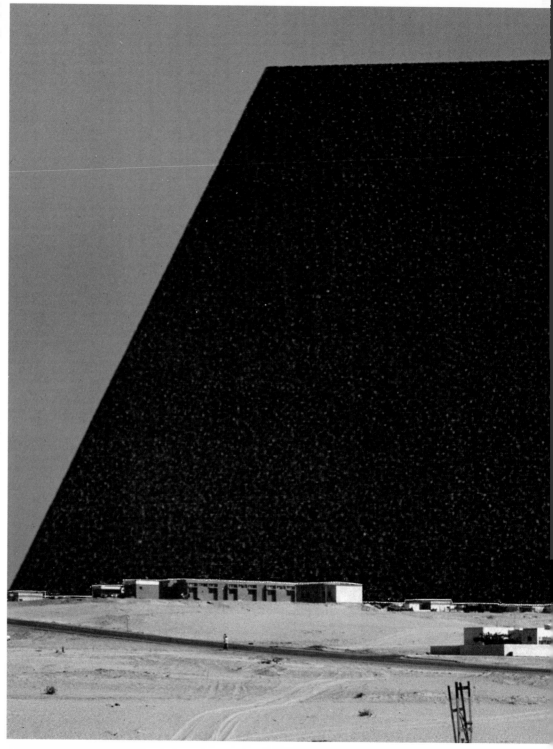

The Mastaba of
Abu Dhabi,
Project for the
United Arab
Emirates. Pho-
tomontage,
1979 (detail).
14″ × 22″.
(photos: W.
Volz)

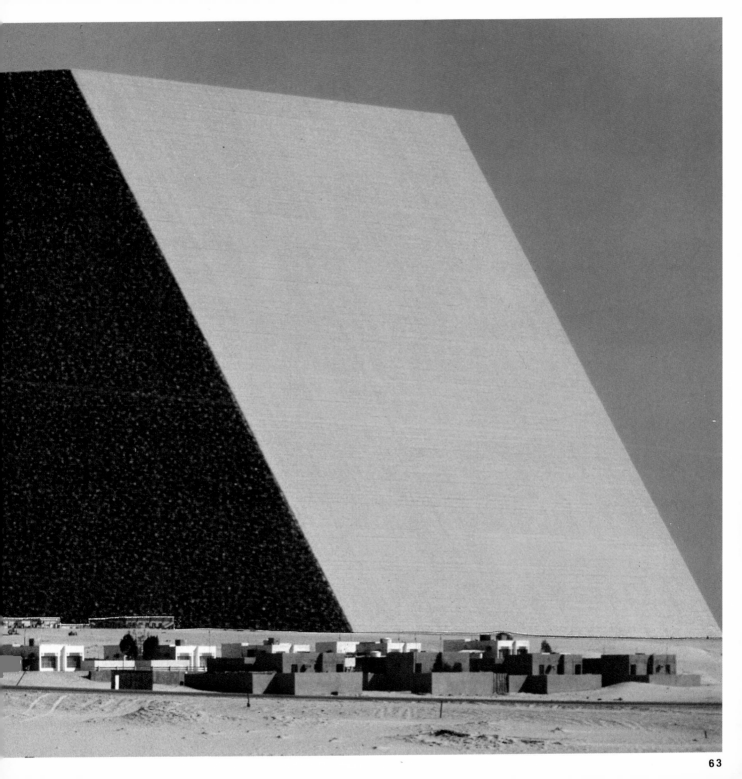

The shadow of the great celestial primate sweeps the world. From Miami to Abu Dhabi in one unwavering step, he streaks across the puddle separating the New World from the Old, ready to knock over the gigantic pile of canned goods stacked up by the Arabian Gulf. The smell of french fries and fuel rises from the earth into the heavens where the great sacred monkeys ogle the colossal pile in the center of the fair below—390,000 oil drums stacked one atop the other, waiting to be knocked over by the kid of the holy trinity on a tour in the land of bumpercars and superlotteries. The kid has an arithmetic problem: How big and how heavy should the bowling ball be? Knowing that each barrel is 40 inches long and 24 inches wide, what specifications should he give Vulcan to be sure that the whole structure will be smashed to smithereens with one blow aimed from somewhere around the top of the Suez Canal?

Like Christo's other projects, this one is built for the heavenly eye. The Miami water lilies—a giant's footprints to the stars. Wrapped Coast—a call for bids from small-time speculators in the ozone. Valley Curtain—the world hoists its sails. Air Package—a Babel of air, alerting the celestial authorities that "we're suffocating down here." The body of the truncated pyramid in Abu Dhabi is missing its apex; from the Eighteenth Dynasty to the present day, humanity has had to remove those spires pointing rather presumptuously into the sky. The heap of oil drums is not a pyramid but a mastaba, a funerary chapel made of the leftovers once we have exhausted the natural resources that keep us alive.

During the past twenty years, the meaning of the neorealist ritual of accumulation has changed. There are no more festive occasions like the rue Visconti barricade. The art of accumulation no longer denounces the excesses of a consumer society but establishes a funerary chapel in "producing societies," dedicated to a civilization crippled by crisis. Where immortal desire once rose, carved into the stone of the pyramids, there is now only the hollow tomb of a consumer society. When the burettes are empty, what priest will sound the warning? At the rate of one biodegradable oil drum per person, the funeral industry certainly ought to be able to manage the ruins of a petroleum civilization.

In the land of the Emirates on the Pirate Coast rises the chapel of the companies that federated these Emirates—Texaco, Gulf . . . the multicolored skeleton of the globe now reduced to the proportions of a truncated pyramid. No oily essence, only framework. This is not an accumulation but a compression. Like the indistinguishable automobiles in César's compressed sculptures, the world now finally looks like what it is: chipped at the edges, eroded, dented. The civilization of offshore and software is already asleep in its oil barrels, resting in the sun within reach of the guns of the fleet anchored in the Straits of Ormuz. Where the nineteenth century celebrated, through the photographs of DuCamp and Francis Frith, the invention of the ruins wherein our civilization recognized its origins, the next century, charging forth at breakneck speed to get a little ahead of its past, counterattacked immediately, finding its reflection in the blueprints of the mastaba.

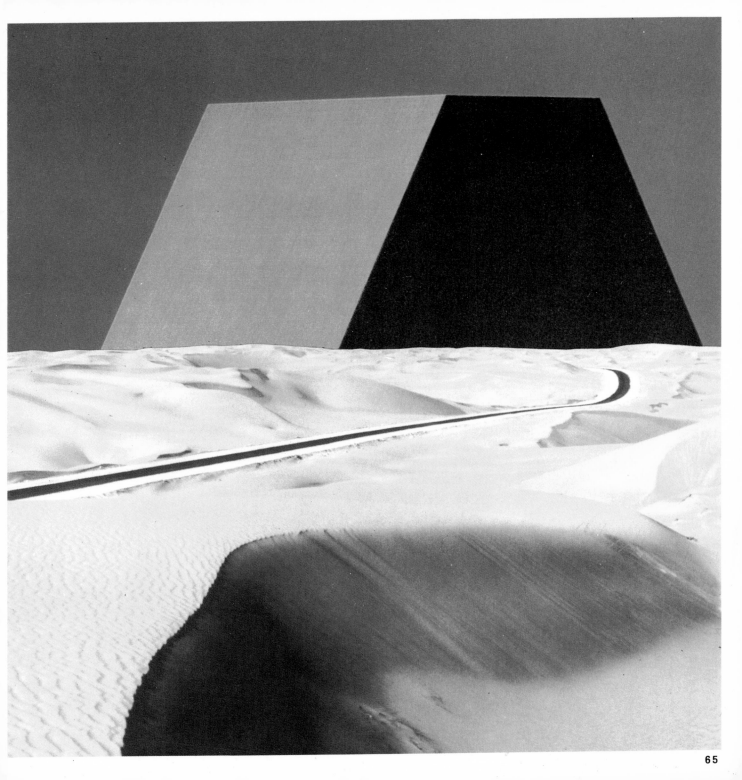

Wrapped Monument to Leonardo da Vinci, Piazza Scala, Milan, 1970. Synthetic fabric and rope. (photo: Shunk-Kender)

Opposite: Wrapped Museum of Contemporary Art, Chicago, 1969. 10,000 square feet of tarpaulin; 3,600 feet of rope. (photo: Shunk-Kender)

Like most artists and writers, Christo Javacheff felt a personal need to circumvent his identity, to try to escape, at least partly, the patronymic imposed on him. What is he doing, the artist who chooses to rename himself, when he selects a new surname, an abbreviation of his name, a slight deformation of his family name, or when he makes his first name his only name? To be sure, he has made a decision to accept renown—but why? Why this infraction of the laws of naming and parentage? He who invents his name does so only out of the fantasy of self-birth. This is a corollary of the desire to create: he who possesses this desire substitutes himself for the laws of filiation and naming in order to constitute himself less his own son than the son of his own works. He claims no other filiation than that which causes him to exist as a son in his own name, that is to say the work he creates and of which he is in a sense the father. From the moment he signs his name to his works, the artist is responding to the ancient canonical definition of the law: Nam de nihilo aliquid facere est jus novum condere—to create from nothing is to establish the law.

In Christo's case, the name he has chosen for himself as an artist duplicates this proposition. Not only does he rename himself, but the name he raises to the dimension of the law, the name which is originally his first name, contains in itself this dislocation of the law. One need not be a cleric (or an expert on the subject) in order to see that in Christo there is Christ, which is to say the unbegotten par excellence, he whom

Saint Ambrose called scarabaeus in cruce. The scarab—the animal designated by the Egyptians as an emblem of eternity, the animal Plutarch and Porphyry said never appeared in female form but forever gave birth to himself, depositing his seed in his droppings, which he carried in a ball between his hind feet, a ball which grew as he did—the raw material of his infinite rebirth. Identified as one who, by his birth, succeeded in escaping the hell of sexual difference and the law of sexual reproduction, Christ is the unbegotten, the flesh begotten of an act that is not copulation.

There may be almost no "creators" in the Western world who, whatever their religion or even if they have no religion at all, have completely escaped the Christ fantasy, which turns an individual into one who, supported by his works, struggles throughout his life to escape the laws of sexual reproduction. The artist names himself so that he may himself incarnate the paternal function, and incarnate it as such, that is to say as wholly symbolic, wholly committed to the transgression of the sexual order. This is not a simple "sublimation" for the artist or writer; when he forces his works to emerge from the void, works that constitute him as the son of something to which he is not linked, he is confronting the impossible. Psychoanalysis is rather timid, and very mechanistic, when it seeks the origin of "artistic sublimation" in a particular kind of mother-child attachment (e.g., the Leonardo symptom), in a duet of neurosis and perversion, in a kind of paradoxical success through

the failure of the paternal metaphor. That art which is born of Catholicism shares with it a greater ambition: to triumph over the sexual, the accursed difference between the sexes, through the desperate effort to incarnate an entirely symbolic filiation.

Like so many others, not only has Christo "chosen" his name, but he is sustained by it. The name he has taken

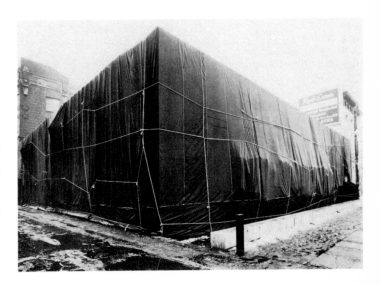

shapes his destiny just as it imprints his works with the shocks necessary to their attack on the sexual. Christo's entire oeuvre, in fact, is marked in an exceptionally transparent way by something we might call the shroud syndrome or the phantasm of resurrection. In the dual act of shrouding and unveiling, there is a latency period in which the object or monument is provisionally dead, a suspension that defines the unveiling as an instant of renaissance, of the reawakening to itself of the object which, absent for a moment, reap-

pears intact from its entombment. By virtue of the shroud draped upon it, the monument gains, on its reappearance into the light of day, a kind of surplus of resemblance, a total identity it could not have acquired had it not passed through a time of purification in death. In this desire to keep the wrapping visible for a few days only, there is an echo that cannot fail to have

repercussions in our culture, a kind of repetition of the myth that lies at the origin of Christianity. Christo's name is the very essence of his work. If the double gesture of veiling and unveiling mimes a victory over death, the subject of this act should be sought in the name through which the artist offers himself the possibility of acting out the fantasy of resurrection. Thus, through this act, the art of painting achieves the capacity for a triumphant death. To announce or expose extremities of painting—or its death—in a seemingly end-

less century that has gone from Duchamp to Yves Klein, Christo, who continues to paint in a quintessentially academic style, uses painting as a means of displaying the veil, or wrapping, which has always and everywhere been the matrix of all painting. We need only recall Parrhosios triumphing over Zeuxis by painting a veil. The veil Christo drapes over his monuments is not, however, borrowed from Greek tradition; his is the veil cast over the corpse of the resuscitated. In Christian culture, the Sacred Shroud and the veil of Saint Veronica can be seen as paradigms for painting itself. Christo uses this paradigm, this etymon, to raise the veil to a position where both veil and painting escape the frame and take possession of the world. Here we see why Christo's works cannot be equated with those of other land-artists. If his art transcends the tradition of hanging, it nonetheless cannot be situated outside or beyond that of painting. It seizes what is essentially and universally the object of painting and deploys it on a grand scale wherein the shroud, or veil, brings painting to its glorious demise. Instead of working himself to death depicting the world on pieces of canvas (yes, the world, always the world, and representation, forever representation—from Malevich's crosses to Klein's cosmogonies), Christo has transferred his drawings onto the world itself, inverting the relationship between reality and fiction, beginning the joyous conquest where painting—in its extremity, in an ultimate wager—undertakes to fictionalize the world.

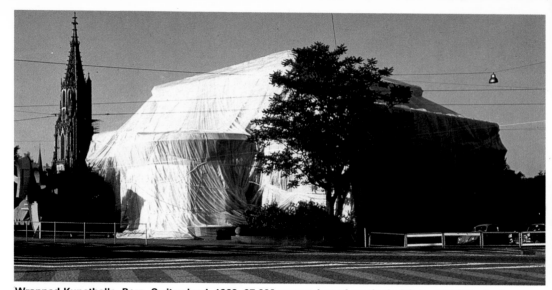

Wrapped Kunsthalle, Bern, Switzerland, 1968. 27,000 square feet of synthetic fabric; 10,000 feet of rope. (photo: T. Cugini)

Wrapped Coast, Little Bay, Australia, 1969. (photo: H. Shunk)

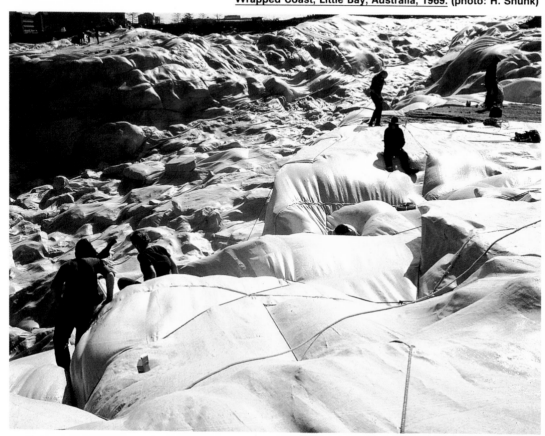

There are, of course, a thousand reasons to scoff at these ideologies which oppose the reactionary desire to create a work—ideologies of the ephemeral, of the action of an instant, supposedly forever lost, but photographed, taped, filmed, and inventoried for the benefit of remembrances to come, like some banal ancestral painting relegated to a dusty corner under the eaves. One argument against the unilateral apologia for the ephemeral is the fact that it is the pure and simple denial of the desire for immortality which we, alas, cannot overcome simply by turning it upside down. One hint of the ephemeral is not enough to withstand the desire for a thousand-year empire. Whether we wish to attain, in effigy a state beyond our own life, or whether we mortify ourselves in the vaguely aesthetic affirmation of no future, death—insurmountable death—remains the referent of both acts.

Christo's work cannot escape that ambivalence which joins, back to back, the temptation of eternity and the praise of the instant. Impressive works like Running Fence or Valley Curtain, set up for a few weeks, then dismantled, leave behind voluminous catalogues inventorying everything, from the tiniest photographic detail to the most tedious paperwork involving the local authorities, from samples of the fabric used to the confidential report of the committee for the protection of the environment, from the picture of Jeanne-Claude, as foreman, directing the worksite to photocopies of the correspondence with the local sheriff. The practice of the ephemeral means ex-

penditure and absence on the one side, accumulation on the other; the positive affirmation of removal compensated for by the desire to lose nothing. People often accuse Christo of "paranoia"; they might exhibit a bit more clinical discernment were they to dismiss, categorically, their obsessions with both retentiveness and self-sacrifice.

The underside of the most extreme experiences models itself on those topological objects where, to reach the reverse side of a point on a surface, no edge need be crossed. Just as love and hate circulate on the same topological surface, so any entity that presupposes its opposite always contains a constitutive ambivalence between the two, a twinlike relationship in which both elements are linked

together. Loss, or absence, is as close to accumulation as the ephemeral is to the eternal. Whether nothing is left that has not been spent or whether nothing remains that has not been accumulated, there will always be an object missing from the accumula-

tion, just as there will always be an object we never quite finish losing. Thus must we qualify the idea that Christo's work belongs wholly on the side of expenditure, for the experience of loss, or absence, always includes the possibility of a "plus value" (in the sense of meaning, or money, or pleasure).

If creating a work is to desire the immortal, then the fantasy of immortality is not inscribed in Christo's work (by definition ephemeral) but in its offshoots, in the scraps and orts which testify to the fact that the work did indeed take place (films, books, photographs). On the other hand, there is something else inscribed in the work itself, something that opposes the fantasy of immortality with a certain access to eternity. Immortality is a temporal concept; the eternal is timeless, incorruptible by any kind of duration. When Christo states that he seeks "the involuntary beauty of the ephemeral," he is not arguing the case of an art that desires to be ephemeral, but is seeking to invest his work with the quality that produces the fleeting singularity of the instant. The ephemeral is not the ultimate aim of the work; rather, it is the work which produces the ephemeral. For on the near side of a given threshold, the ephemeral is not the shortest possible length of time; it is the elusive instant that evades time altogether and that is, paradoxically, our only way into eternity.

To seek "the involuntary beauty of the ephemeral" is to create the advent of surprise, to practice the art of accident, as in those incomparable moments when an object, a landscape, an ordi-

nary form appear suddenly for themselves alone, then vanish just as quickly, unreconstructable as they were an instant before. Or in those moments when a "lapsus" occurs in the visible world and familiar forms appear not just as they are in themselves, but as they relate to other forms. Or when, stripped of their ties to the rest of the visible world, things begin to exist for themselves, as objects demanding that we see them for themselves alone. Christo's works have the eeriness and the transience of the apparition; each intrudes into the real like a preposterous anomaly, an untimely hallucination that upsets the order of the world for a moment and then vanishes, returning things to their former familiarity, yet leaving them definitively haunted by the intrusion. Something happened here, something unrepeatable, something that will return, perhaps, elsewhere, in some other place, and will move new crowds before another hallucinated landscape, another apparition. What happened here happened once only; it will not happen again, except in the words that transmit it from generation to generation, like all other corners of the world which have become theaters of legends, the chosen places of authors or mythical gods. Even if all pictures of Christo's work were erased or burned, it would live on in memory to the degree that it irradiated, one day, the real with the fantastic: "A long time ago, so long ago that your father's father and even his father before him did not know this thing himself but had it told to him and then taught it in turn, a magician built a great wall of

cloth. It was 2 million square feet and ran for 24½ miles, from the farm up there to the sea, where the old ones say it was buried, where it plunged into the waves and vanished forever. And masses of people came to see it, so many as had not been here since the time of the conquest. The wall ran through the field down there, then across that hill, then rushed down the other side and began running in the distance. No less than two thousand posts were brought here in the course of a day and a night, two thousand posts four times higher than our fence posts. . . ."

If we have no difficulty imagining this event as legend, it is not only because of its monumentality but also because of its historical similarity to the apparition, because its transitory presence makes it a memory-generator. Ephemeral, it immediately enters the context of time past, of time forever lost. In other words, the work immediately assumes the fleeting value of an event, and thus it enters instantly into memory. A painting, we know, exists somewhere; we have seen it, and it is possible to see it again. It is not that lost or vanished object we have seen but know we will never see again. Because it has the structure of an apparition, the event immediately enters the category of legend: "In 1983, in Florida, I saw pink water lilies floating around the islands in Biscayne Bay," the traveler will remark, just as another might say, "I was there the day the people from outer space landed," or "I was strolling along the quai des Grands-Augustins when I saw the Pont-Neuf collapse." Its

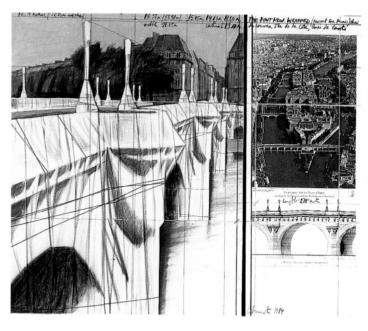

The Pont-Neuf Wrapped, Project for Paris. Collage, 1984, in two parts. 28" × 22" and 28" × 11". Pencil, fabric, twine, pastel, charcoal, crayon, photograph, and technical data. (photo: Eeva-Inkeri)

transience and uniqueness make the work a legendary event, just like natural disasters or significant historical facts, like anything that lends itself to storytelling and is transmitted by memory.

Thus do Christo's works escape the closed world of art. If his drawings and books assure, in traditional fashion, the dissemination of his images and ideas within artistic circles, each of his realizations is, in its own particular place, a point of departure for a remembrance, a history, a story. From Little Bay to Miami, from Paris to Colorado, from Milan to Abu Dhabi, everywhere the events occurred they have become part of the local memory, perpetuating themselves as narrative. Because the event overshadows the monument, the work generates a story. And because the fabulous surpasses the "reality," the story continues to be passed on, as if there were a law of narrative that a story perpetuates itself in time in inverse proportion to the event itself, as if it were the essence of the apparition, the innate peculiarity of all things that elude the visible, to survive in the word.

The Pont-Neuf Wrapped, Project for Paris. Collage 1979. 28″ × 22″. Pencil, fabric, twine, charcoal, pastel, photostat from a photograph by W. Volz, and technical data.

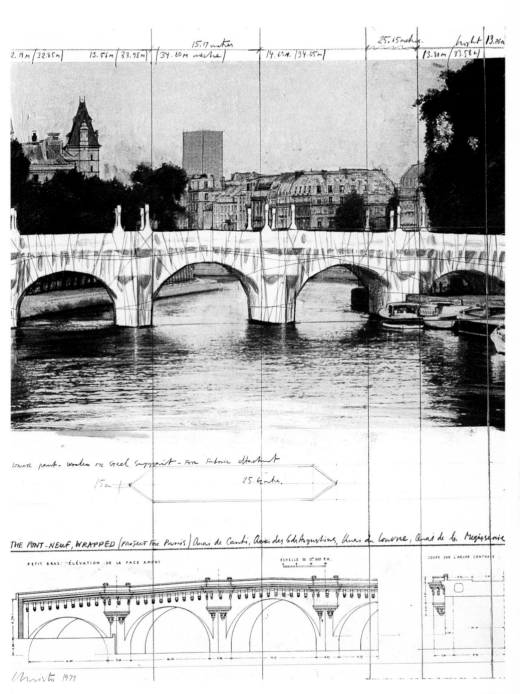

The Umbrellas, Project for Japan and Western U.S.A.

Christo and Jeanne-Claude Christo in Miami, 1983. (photo: W. Volz)

The Umbrellas /project for 6-8 miles - 3000 umbrellas hight 12 feet diameter 18 feet/ Christo 1985

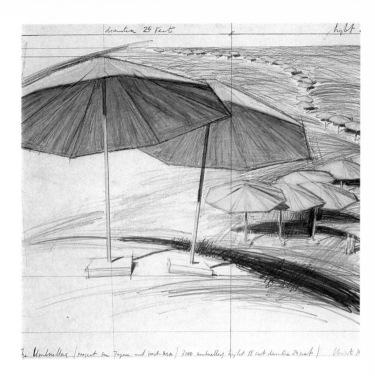

diameter 24 feet hight .

The Umbrellas /project for Japan and West-USA/ 3000 umbrellas hight 18 feet diameter 24 feet / Christo 1985

The Umbrellas,
Project for Japan and Western U.S.A.

Left:
The Umbrellas, Project for Six to Eight Miles, Three Thousand Umbrellas. Collage, 1985. 30½″ × 26¼″. Pencil, fabric, and crayon. (photo: Eeva-Inkeri)

Right:
The Umbrellas, Project for Japan and Western U.S.A. Collage. 26¼″ × 30½″. Pencil, charcoal, and fabric. (photo: Eeva-Inkeri)

Thousands of umbrellas, 18 feet high and 24 feet in diameter, will meander in the landscape for several miles, simultaneously in Japan and the western part of the United States, as a two-site project.

The octagonal umbrellas will run alongside roads and riverbanks, crossing rural areas, fields, and intersections in suburban areas in both countries.

Sometimes in clusters, then in a line or spaced from each other, The Umbrellas occasionally will slightly tilt according to the slope of the terrain on which they rest.

As I have done for all my other temporary works of art, The Umbrellas shall be entirely financed by me through the sale of my preparatory drawings, studies, and early works.

For a period of two weeks, The Umbrellas will be seen, approached, and enjoyed either by car from a distance and closer as they border the road, or in a promenade route under the umbrellas in their luminous shadows.

—Christo
April 1985

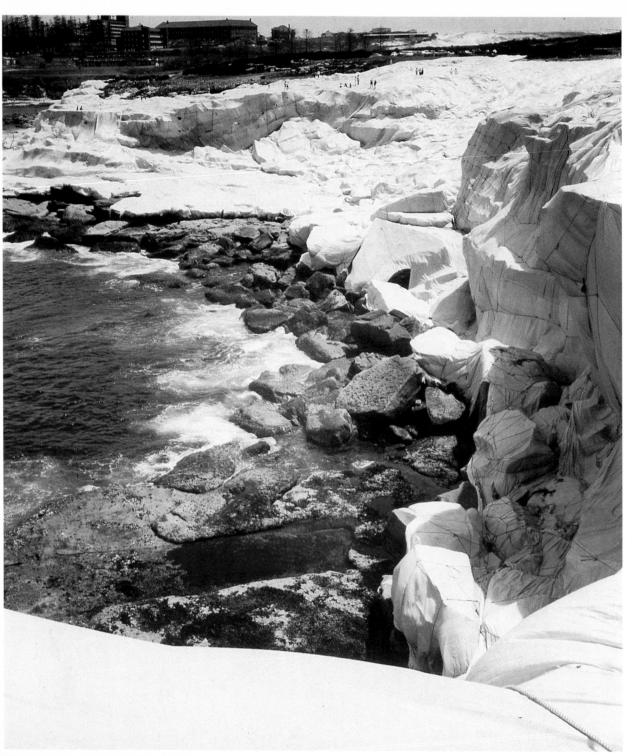

Wrapped Coast, Little Bay, Australia, 1969, One Million Square Feet. One million square feet of erosion control mesh. Coordinator: John Kaldor. (photo: Shunk-Kender)

Surrounded Islands, Biscayne Bay, Greater Miami, Florida, 1980–1983. (photo: W. Volz)

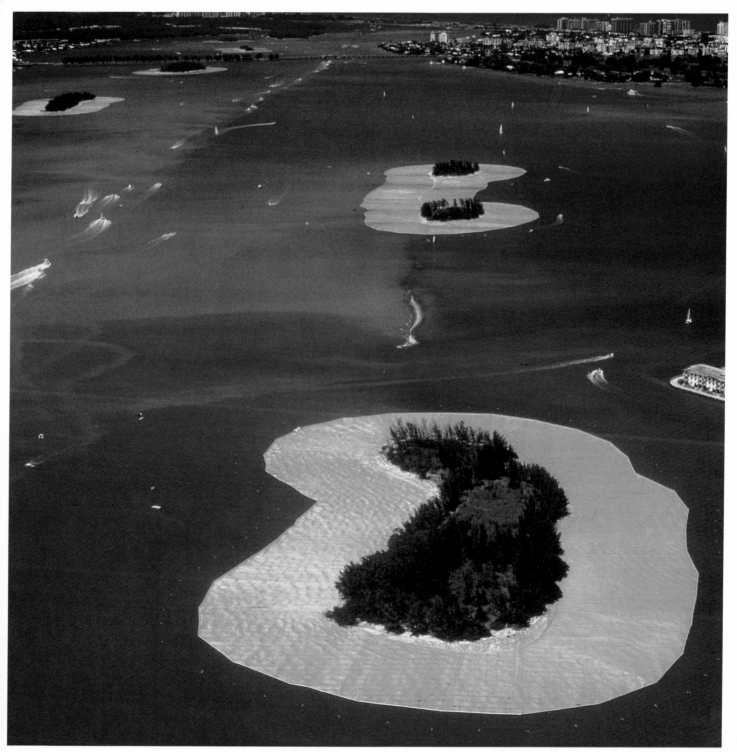

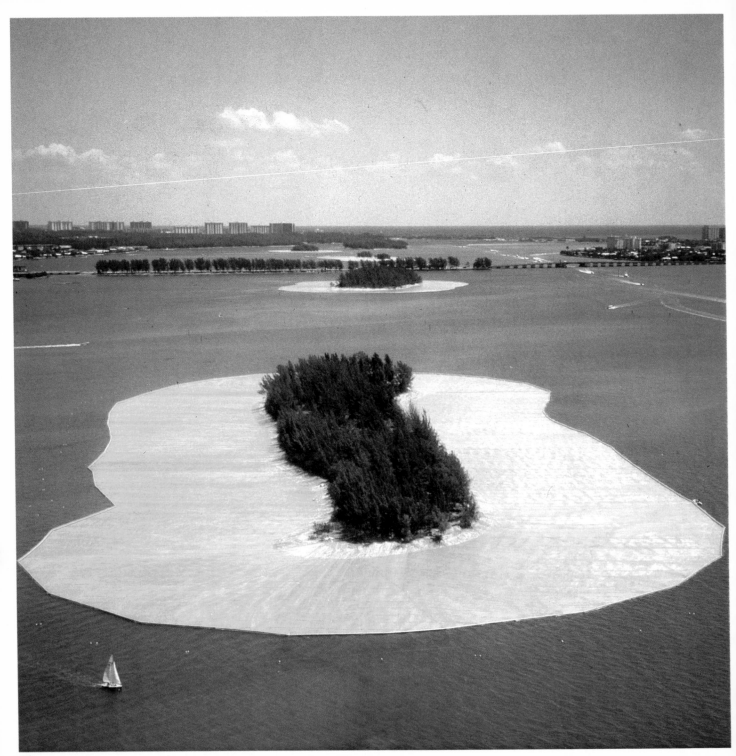

Surrounded Is-
lands. (photo:
Jeanne-Claude)

Valley Curtain,
Grand Hog-
back, Rifle,
Colorado, 1970
–1972. (photo:
H. Shunk)

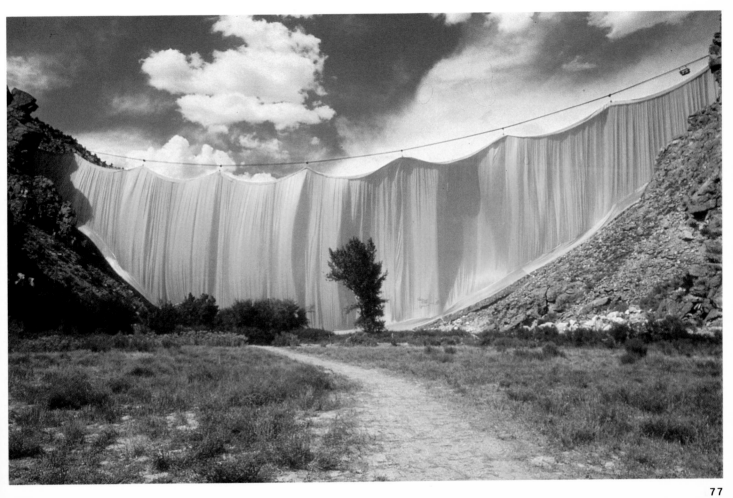

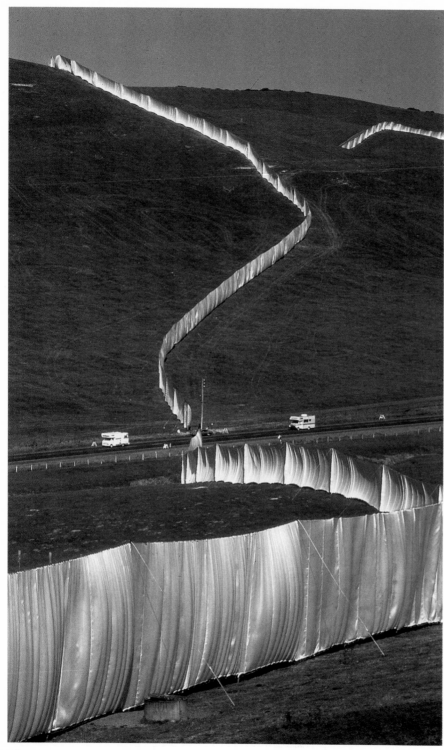

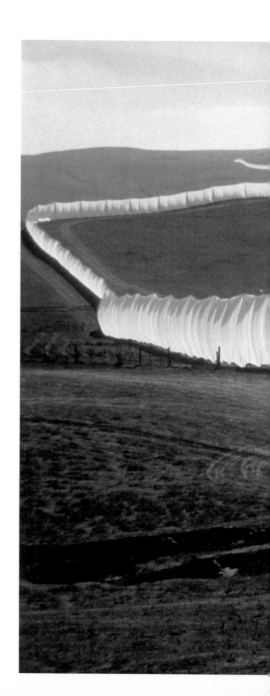

Running Fence, Sonoma and Marin Counties, California, 1972–1976.

Height: 18 feet; length: 24½ miles. (photos: W. Volz)

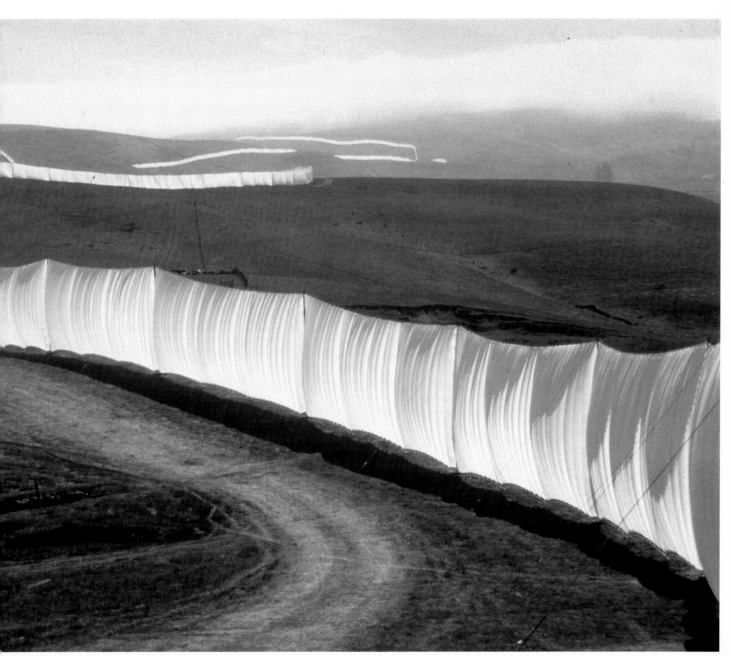

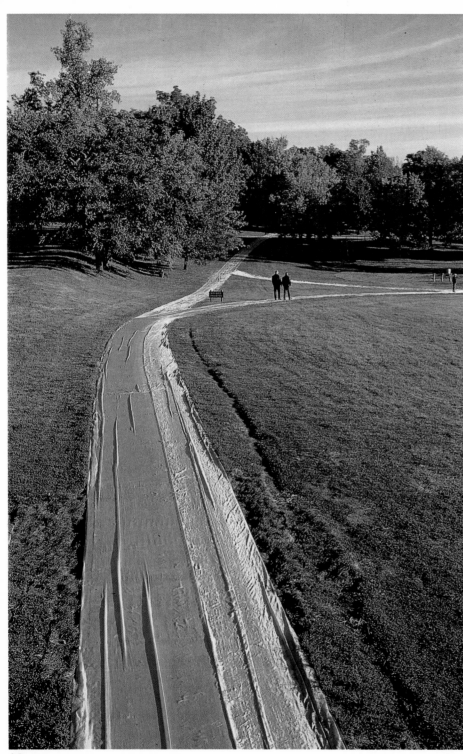

Wrapped Walk Ways, Loose Memorial Park, Kansas City, Missouri, 1977–1978. 15,000 square yards of fabric on 2.7 miles of paths. (photo: W. Volz)

PARTICULARS OF EARLIER PROJECTS

Wrapped Kunsthalle, Bern, Switzerland, 1968

A Swiss art museum, the Kunsthalle in Bern, gave Christo his first opportunity to fully package an entire building. July 1968 marked the fiftieth anniversary of the museum, and the event was celebrated with an international group show of environmental works by twelve artists. As one of the dozen participants, Christo showed nothing inside the museum, but literally packaged the entire show. "I took the environments by eleven other artists," he remarked with amusement, "and packaged them. I had my whole environment inside." Christo shrouded the Kunsthalle with 27,000 square feet of reinforced polyethylene, which was left over from the discarded first skin of the Kassel balloon, secured it with 10,000 feet of nylon rope, and made a slit in front of the main entrance so visitors could enter the building. The Kunsthalle is a bulky-looking building, despite its curved walls and sloping roof, but its hulking silhouette was considerably softened by the mantle of translucent polyethylene. The only architectural elements that remained visible with any sharpness and clarity were the contours of the roof and cornices. The sides of the building were luxuriously swagged, and the plastic veiling was continually animated by soft, billowing folds and an ever-changing pattern of glimmering highlights.

The wrapping process took six days, with the help of eleven construction workers. Because no nails could be driven into the building, special wooden supports had to be built for fastening the plastic to the building. At one point, to facilitate work on the roof, the local fire brigade was called upon to lend a hydraulic ladder. Insurance companies refused to underwrite the Kunsthalle and its valuable contents during the period it was to be wrapped, so to guard against possible fire and vandalism, museum director Harald Szeemann had six watchmen posted around the building at all times. As this proved to be quite expensive, the building was unwrapped after one week.

—David Bourdon, Christo

5,600 Cubic Meter Package, Documenta IV, Kassel, West Germany, 1968

Height: 280 feet.

Diameter: 33 feet.

Weight: 14,000 pounds.

Skin: 22,000 square feet of Trevira fabric coated with PVC.

Ropes: 12,000 feet of one-inch-diameter polyethylene.

Air Pressure: 0.14 Psig.

Guy Wires: 6,000 feet of ⅞-inch steel cable.

6 concrete foundations on a 900-foot-diameter circle.

Total Weight: 180 tons.

Erected between 4 A.M. and 2 P.M. on August 3, 1968, using five truck-cranes.

Duration: 75 days. The project was financed by the artist through the sale of his preparatory drawings, collages, scale models, studies, and early works.

Engineer: Dimiter Zagoroff.

—Christo

Wrapped Coast, Little Bay, Australia, 1969, One Million Square Feet

Little Bay, the property of Prince Henry Hospital, is located 9 miles southeast of the center of Sydney. The cliff-lined shore area that was wrapped was approximately 1½ miles in length, 150 to 800 feet in width, and 85 feet in height. At the northern part it was cliffs, and at sea level at the southern part sandy beach.

One million square feet of erosion control mesh (synthetic woven fiber usually manufactured for agricultural purposes) was used for the wrapping. Thirty-five miles of polypropylene rope, 1¼ inches in circumference, tied the fabric to the rocks.

Ramset guns fired 25,000 charges of fastenings, threaded studs, and clips to secure the rope to the rocks.

Mr. N. Melville, a retired major of the Army Corps of Engineers, was in charge of the construction site.

Fifteen professional mountain climbers, 110 laborers, students from Sydney University and East Sydney Technical College, as well as some Australian artists and teachers, put in 17,000 manpower hours over a period of four weeks.

The project was financed by the artist through the sale of his preparatory drawings, collages, scale models, studies, and early works.

The coast remained wrapped for a period of ten weeks, then all materials were removed and the site was restored to its original condition.

John Kaldor was coordinator of the project.

—Christo

Valley Curtain, Rifle, Colorado, 1970–1972

On August 10, 1972, in Rifle, Colorado, a group of thirty-five construction workers and sixty-four temporary helpers, including art students, college students, and itinerant art workers, raised an orange nylon curtain across Rifle Gap, 7 miles north of Rifle on Highway 325. At 11 A.M., they tied down the last of twenty-seven ropes that secured the 200,000 square feet of woven orange nylon fabric to its moorings.

Valley Curtain was designed by Unipolycon of Lynn, Massachusetts, and the Ken R. White Company of Denver, Colorado. It was built by A and H Builders Inc. of Boulder, Colorado, under the site supervision of Henry B. Leininger.

By suspending the curtain at the width ranging from 1,250 to 1,368 feet and a height curving from 365 feet at each end to 182 feet at the center, the curtain remained clear of the slopes and the valley bottom.

A 10-foot skirt attached to the curtain visually completed the area between the thimbles and the ground.

An outer cocoon was placed around the fully fitted curtain to protect it in transit and at the time of its raising into position and securing the eleven cable-clamp connections at the four main upper cables.

An inner cocoon, integral to the curtain, provided added insurance.

The bottom of the curtain was laced to a 3-inch-diameter Dacron rope from which the control and tie-down lines ran to the twenty-seven anchors.

The Valley Curtain project took twenty-eight months to complete. It was financed by the artist through the sale of his preparatory drawings, collages, scale models, studies, and early works.

On August 11, twenty-eight hours after completion, of the Valley Curtain, a gale estimated in excess of 60 mph made it necessary to start the removal.

—Christo

Running Fence, Sonoma and Marin Counties, California, 1972–1976

Running Fence, a fence of white nylon fabric 18 feet and 24½ miles long, extended east-west near Freeway 101, north of San Francisco, on the private properties of fifty-nine ranchers, following the rolling hills and dropping down to the Pacific Ocean at Bodoga Bay. It crossed fourteen roads and the town of Valley Ford, leaving passage for cars, cattle, and wildlife, and was designed to be viewed by following 40 miles of public roads, in Sonoma and Marin Counties. It was completed on September 10, 1976.

The art project involved forty-two months of collaborative efforts, the ranchers' participation, eighteen public hearings, three sessions at the Superior Courts of California, the drafting of a 450-page environmental-impact report, and the temporary use of the hills, the sky, and the ocean.

Conceived and financed by Christo, Running Fence was made of 165,000 yards of heavy woven white nylon fabric, hung from a steel cable strung between 2,050 steel poles (each 21 feet long and 3½ inches in diameter) embedded 3 feet into the ground, using no concrete and braced laterally with guy wires (90 miles of steel cable) and 14,000 earth anchors. The top and bottom edges of the 2,050 fabric panels were secured to the

upper and lower cables by 350,000 hooks. All parts of Running Fence's structure were designed for complete removal. No visible evidence of Running Fence remains on the hills of Sonoma and Marin Counties. The project was financed by the artist through the sale of his preparatory drawings, collages, scale models, studies, and early works.

As had been agreed with the ranchers and with county, state, and federal agencies, the removal of Running Fence started fourteen days after its completion and all materials were given to the ranchers.

—Christo

The Wall—Wrapped Roman Wall, Rome, 1974

Height: 50 feet.

Length: 850 feet.

Width: varying between 14 and 19 feet.

Materials: woven polypropylene fabric and Dacron rope.

The project was financed by the artist and by the Contemporanea Exhibition, Rome.

Situated at the end of the Via Veneto, one of the busiest avenues of Rome, and at the edge of the gardens of the Villa Borghese, the 2,000-year-old wall was built by the Emperor Marcus Aurelius, and once surrounded the city of Rome.

For a period of forty days, in February–March 1974, the wall was wrapped in polypropylene and rope, covering both sides of the wall, the top, and the arches.

Of the four arches that were wrapped, three arches are heavily used by car traffic and one is reserved for pedestrians.

—Christo

Wrapped Walk Ways, Loose Memorial Park, Kansas City, Missouri, 1977–1978

Wrapped Walk Ways is a Christo project for Loose Memorial Park in Kansas City, Missouri. It is composed

of 143,000 square feet of orange nylon, spread out over 11,000 square feet of paths and walkways in a traditional park. The execution of the project began on Monday, October 2, and ended on Wednesday, October 4, 1978. The Nelson Gallery Contemporary Art Society helped obtain the construction permit. Eighty-four people, including thirteen construction workers and four professional seamstresses, were employed by A. L. Hubar and Son, a Kansas City real estate company, to install the fabric. Thirty-four thousand steel nails, driven through small stainless steel holes punched into the fabric, and forty thousand staples which attached the fabric to the wooden steps, were used to hold the cloth in place on the ground. 16,500 yards of seams and hems were sewn beforehand in a factory in West Virginia; afterward, professional seamstresses, along with several assistants and some portable sewing machines, arrived at Loose Park to complete the work.

The project was financed by the artist through the sale of preparatory drawings, collages, scale models, studies, and early works.

The installation remained in the park until October 16, after which the fabric was removed and donated to the Kansas City Parks Department.

—Christo

The Mastaba of Abu Dhabi, Project for the United Arab Emirates

(In progress: 1978–)
- The Mastaba of Abu Dhabi will be taller and more massive than the Great Pyramid near Cairo.

- It will be the symbol of the Emirates and the age of oil.

- The only purpose of this monument is to be itself.

- The Mastaba will be made of 390,500 oil barrels. Hundreds of bright colors, as vivid as those of the Islamic mosaics, will give a constantly changing visual experience according to the time of day and the quality of the light.

- The grandeur and vastness of the land will be reflected in the gran-

deur and majesty of the Mastaba, which will be 984 feet wide, 738 feet deep, and 492 feet high.

- The Mastaba will be constructed of materials indigenous to the area: inside, natural aggregates and cement to form a concrete structure with a sand core; and outside, an overall surfacing of 55-gallon stainless steel oil barrels of various bright colors.

- All barrels, on the four sides and on the top, will be installed so that they are lying horizontally on their sides.

- The two 984-foot-wide sides will be vertical, showing the circular heads of the colored barrels.

- The two 738-foot-ends will be sloping at the 60-degree natural angle of stacked barrels, showing the curved sides of the barrels.

- The top of the Mastaba will be a horizontal surface 416 feet wide and 738 feet deep, showing the rounded length of the barrels.

- The volume of the Mastaba will be such that many 48-story skyscrapers could easily fit into its massiveness.

It is suggested that the Mastaba be situated on a slightly rising plain to allow viewers the full impact of the Mastaba as they approach by foot, by automobile, or by airplane.

There will be no ingress except for a passageway to the elevators to take visitors to the top, 492 feet above the ground. From there they will enjoy superb views, being able to see approximately 35 miles across the countryside.

The area adjacent to the walkways approaching the Mastaba will be like an oasis to the visitor, with flowers and grass. There will also be palm, eucalyptus, and thorn trees and other shrubbery surrounding the Mastaba at a distance to serve as a windbreak minimizing the force of the sand and windstorms.

Within this distant area there could be a complex with a worship room, parking and facilities for visitors, and lodging for the curator and guardians.

—Christo

The Pont-Neuf Wrapped, Paris, 1975–1985

On September 22, 1985, a group of three hundred professional workers completed Christo's temporary work of art The Pont-Neuf Wrapped.

They had deployed 440,000 square feet of woven polyamide fabric, silky in appearance and golden-sandstone in color, covering:

- The sides and vaults of the twelve arches, without hindering river traffic.

- The parapets down to the ground.

- The sidewalks and curbs; pedestrians were easily able to walk on the fabric.

- All the street lamps on both sides of the bridge.

- The vertical part of the embankment of the western tip of the Ile de la Cité.

- The esplanade of the "Vert-Galant."

The fabric is restrained by 42,900 feet of rope and secured by 12.1 tons of steel chains encircling the base of each tower, three feet under water.

The "Charpentiers de Paris," headed by Gérard Moulin, with French subcontractors, were assisted by the U.S. engineers who have worked on Christo's previous projects: Vahé Aprahamian, James Fuller, John Thomson, and Dimiter Zagoroff, under the direction of Theodore Dougherty.

Johannes Schaub, the project's director, had submitted the work method and detailed plans and received approval for the project from the authorities of the City of Paris, the Department of the Seine, and the State.

In crews of forty, six hundred monitors worked around the clock maintaining the project and giving information, until the removal of the project on October 7.

As with all his other projects, all expenses related to The Pont-Neuf Wrapped were borne by the artist himself, through the sale of his preparatory drawings and collages as well as earlier works.

Begun under Henri III, the Pont-Neuf was completed in July 1606, during the reign of Henry IV. No other bridge in Paris offers such topographical and visual variety, today as in the past. From 1578 to 1890, the Pont-Neuf underwent continual changes and additions of the most extravagant sort, such as the construction of shops on the bridge under Soufflot and the building, demolition, rebuilding, and once again demolition of the massive rococo structure which housed the Samaritaine's water pump. Wrapping the Pont-Neuf continues this tradition of successive metamorphoses by giving the bridge a new sculptural dimension and transforming it, for fourteen days, into a work of art itself. Ropes held down the fabric to the bridge's surface and maintained the principal shapes, accentuating relief while emphasizing proportions and details of this bridge which joins the left and right banks and the Ile de la Cité, the heart of Paris for over two thousand years.

—Christo

Wrapped Reichstag, Project for Berlin

(In progress: 1972–)

The wrapping of the building of the German Reichstag will be a temporary work of art, to remain fourteen days in September.

The choice of Berlin and specifically of the Reichstag, determined the project itself: Because Berlin is the site of the physical encounter of East and West, of two value systems and ways of life, it has the richest and most varied texture of any town in the world.

The Reichstag is situated on the limit of that space and stands up in an open, strangely metaphysical area. Built in the late nineteenth century, burned in 1933, almost destroyed in 1945, and restored in the sixties, the Reichstag has undergone continuous changes and perturbations, but has always remained the symbol of democracy.

A high-strength synthetic woven fabric that meets the prescribed standards of fire retardation and Dacron rope will be used for the wrapping of

the Reichstag. Each façade will be covered by five tailor-made fabric panels. Attachment points for the fabric and the ropes will be made using expanding columns that permit installation and removal without altering the building. All vulnerable statues and ornaments will be protected by specially fabricated cage-like structures.

The work will be completed in three phases. The first phase includes all off-site work such as cutting and sewing the fabric panels and fabrication of the cages and attachment columns. In the second phase, the attachment columns and protective cages will be installed and the rolls of fabric will be moved and positioned on the roof terrace.

With these low-visibility preparations completed, the final phase can be undertaken in which the fabric is unfurled from above and secured in a matter of four to five days.

The shiny light-colored fabric will increase the building's volume by almost 30 percent. The folds of the fabric will respond to the force and direction of the wind and will make the building seem to be strangely and constantly breathing. The daylight will be reflecting and changing throughout the day, altering the surrounding perspective of the old buildings and the new structures around the Tiergarden.

The Wrapped Reichstag project will be entirely financed by Christo through the sale of his preparatory drawings, collages, scale models, studies, and early works. Neither the City of Berlin nor the federal government of Germany shall bear any of the expenses of the project.

A written contract shall be drafted between the City of Berlin, the Bonn authorities, and our organization. The contract shall require us to provide:

1. Personal and property liability insurance holding the City of Berlin and the federal government legally free of liability.

2. Removal bond providing funds for the complete and satisfactory removal of the wrapping materials.

3. Full cooperation with the community of Berlin, the various de-

partments of the City of Berlin, and the federal agencies in Bonn.

4. Paid employment of local residents.

5. Clearance and access for the usual activities in the Reichstag building.

The Wrapped Reichstag project represents not only a few years of efforts in an artist's life, but also years of teamwork. It involves politicians, businessmen, artists, and people from all points of the social spectrum, from both West and East. The communal energy the project will generate is an important part of the dialogue that has become vital for the Reichstag project.

The physical reality of the Wrapped Reichstag will be a dramatic and beautiful experience. The fabric is a fragile material, like clothing or skin; it will have the special beauty of impermanence.

—Christo

Surrounded Islands, Biscayne Bay, Greater Miami, Florida, 1980–1983

On May 7, 1983, the installation of Surrounded Islands was completed. In Biscayne Bay, located between the City of Miami, North Miami, the Village of Miami Shores, and Miami Beach, eleven of the islands situated in the area of Bakers Haulover Cut, Broad Causeway, 79th Street Causeway, Julia Tuttle Causeway, and Venetian Causeway were surrounded with 6.5 million square feet of pink woven polypropylene fabric. The fabric covered the surface of the water, floating and extending out 200 feet from the island into the bay. It had been sewn into seventy-nine patterns to follow the contours of the eleven islands.

For two weeks Surrounded Islands, situated over 7 miles altogether, could be seen, approached, and enjoyed by the public from the causeways, the land, the water, and the air. The luminous pink color of the shiny fabric was in harmony with the tropical vegetation of the uninhabited, verdant islands, the light of the

Miami sky, and the colors of the shallow waters of Biscayne Bay.

From April 1981, attorneys Joseph Z. Fleming, Joseph W. Landers, marine biologist Dr. Anitra Thorhaug, ornithologists Drs. Oscar Owre and Meri Cummings, mammal expert Dr. Daniel Odell, marine engineer John Michel, four consulting engineers, and builder-contractor Ted Dougherty of A & H Builders, Inc., worked on the preparation of the Surrounded Islands. As with Christo's previous art projects, Surrounded Islands was entirely financed by the artist, through the sale of his preparatory pastel and charcoal drawings, his collages, and early works.

Permits had been obtained from the following governmental agencies: the Governor of Florida and the Cabinet; the Dade County Commission; the Department of Environmental Regulation; the City of Miami Commission; the City of North Miami; the Village of Miami Shores; the U.S. Army Corps of Engineers; the Dade County Department of Environmental Resources Management. From November 1982 until April 1983, 6,500,000 square feet of woven polypropylene fabric were sewn in the rented Hialeah factory into seventy-nine different patterns to follow the contours of the eleven islands. A flotation strip was sewn in each seam. The sewn sections were accordion-folded at the Opa Locka Blimp Hangar to ease the unfurling.

The outer edge of the floating fabric was attached to a 12-inch-diameter octagonal boom, in sections, of the same color as the fabric. The boom was connected to the radial anchor lines which extend from the anchors at the island to the 610 specially made anchors, spaced at 50-foot intervals, 250 feet beyond the perimeter of each island, driven into the limestone at the bottom of the bay. Earth anchors were driven into the land, near the foot of the trees, to secure the inland edge of the fabric, covering the surface of the beach and disappearing under the vegetation.

The floating rafts of fabric and booms, varying from 12 to 22 feet in width and from 400 to 600 feet in length, were towed through the bay to each island. There are eleven islands, but

in two areas Christo surrounded two islands together as one configuration.

On May 4, 1983, out of a total work force of 430, the 310 members of the unfurling crew began to blossom the pink fabric. Surrounded Islands was tended day and night by 120 monitors in inflatable boats.

Surrounded Islands was a work of art that underlined the various elements and ways in which the people of Miami live, between land and water.

—Christo

The Gates, Project for Central Park.

(In progress 1980–)

The Gates will be 15 feet high with a width varying from 9 to 28 feet, and will follow the edges of the walkways, perpendicular to the selected foot-paths of Central Park. Attached to the top of each steel gate, spaced at 9-foot intervals, the fabric will come down to 5 feet 6 inches from the ground, allowing the synthetic woven panels to wave horizontally towards the next gate.

The Gates are planned to remain for fourteen days in the last two weeks of October 1983 or 1984, after which the 27-mile-long work of art shall be removed and the ground restored to its original condition.

The Gates will be entirely financed by the artist through the sale of his preparatory drawings, collages, scale models, studies, and early works.

Neither the City nor the Park shall bear any of the expenses for The Gates.

A written contract shall be drafted between the Department of Parks and our organization based upon the agreements made in California with all relevant governmental agencies at the time of the construction of the Running Fence project, which brought complete satisfaction to the authorities and international attention to that area.

The contract shall require us to provide:

1. Personal and property liability insurance holding the Depart-

ment of Parks legally free of liability.

2. Environmental impact statement would be prepared if requested by the Park.

3. Removal bond providing funds for complete restoration of the grounds.

4. Full cooperation with the community boards, the Department of Parks, the New York City Arts Commission, and the Landmarks Commission.

5. Employment of local Manhattan residents.

6. Clearance for the usual activities in the Park and access of rangers, maintenance, clean-up, police, and emergency service vehicles.

7. Direct cost of the Park's supervision shall be charged to us.

8. The configuration of the path of The Gates shall be selected together with the Department of Parks.

9. No vegetation or rock formations will be disturbed.

10. Only vehicles of small size will be used and will be confined to the perimeter of existing walkways during installation and removal.

11. Every precaution will be taken in scheduling The Gates so as not to interfere with any wildlife patterns.

12. All holes shall be professionally backfilled with natural material, leaving the ground in good condition, and the results will be inspected by the Department of Parks, who will be holding the bond until full satisfaction.

13. Financial help shall be given to the Department of Parks in order to cover any possible additional clean-up task, secretarial work, or any expenses that might occur in direct relation to The Gates.

Full-size prototype tests are being conducted by our engineers on the steel frames, their bottom supports, and the fabric panel connections.

By uplifting and framing the space above the walkways, the luminous fabric of The Gates will underline the organic design in contrast to the geometric grid pattern of Manhattan and will harmonize with the beauty of Central Park.

—Christo

1935
Born Christo Javacheff, June 13, Gabrovo, Bulgaria.

1952–56
Studied at Fine Arts Academy, Sofia.

1956
Arrival in Prague.

1957
One semester's study at the Vienna Fine Arts Academy.

1958
Arrival in Paris. Packages and Wrapped Objects.

1961
Project for the Packaging of a Public Building.
Stacked Oil Drums and Dockside Packages in Cologne Harbor.

1962
Iron Curtain—Wall of Oil Barrels blocking the rue Visconti, Paris.
Stacked Oil Drums in Gentilly, near Paris.
Wrapping a Girl, London.

1963
Showcases.

1964
Establishment of permanent residence in New York City.
Store Fronts.

1966
Air Package and Wrapped Tree, Stedelijk van Abbemuseum, Eindhoven, Netherlands.
42,390 Cubic Feet Package, Walker Art Center, Minneapolis School of Art.

1968
Packed Fountain and Packed Medieval Tower, Spoleto.
Packaging of a public building: Kunsthalle, Bern.
5,600 Cubic Meters Package, Documenta 4, Kassel, an air package 280 feet high, 33 feet in diameter, supported by cables anchored in six concrete foundations arranged in a 900-foot-in-diameter circle.
Corridor Store Front, total area 1,500 square feet.
1,240 Oil Drums Mastaba, and Two Tons of Stacked Hay, Philadelphia Institute of Contemporary Art.

BIBLIOGRAPHY

1969

Packed Museum of Contemporary Art, Chicago.
Wrapped Floor, 2,800-square-foot dropcloths, Museum of Contemporary Art, Chicago.
Wrapped Coast, Little Bay, One Million Square Feet, Sydney, Australia: erosion control fabric and 36 miles of ropes.
Project for stacked oil drums: Houston Mastaba, Texas, 1,249,000 drums.
Project for Closed Highway.

1970

Wrapped Monuments, Milan: Monument to Victor Emmanuel, Piazza Duomo; Monument to Leonardo da Vinci, Piazza Scala.

1972

Wrapped Reichstag, Project for Berlin, in progress.
Valley Curtain, Grand Hogback, Rifle, Colorado, 1970–72. width: 1,250–1,368 feet; height: 185–365 feet; 200,000 square feet of nylon polyamide; 110,000 pounds of steel cables; 800 tons of concrete.

1974

The Wall, wrapped Roman wall, Via Veneto and Villa Borghese, Rome.
Ocean Front, Newport, Rhode Island: 150,000 square feet of floating polypropylene over the ocean.

1976

Running Fence, Sonoma and Marin Counties, California, 1972–76. 18 feet high, 24½ miles long. Two million square feet of woven nylon fabric. 90 miles of steel cables. 2,050 steel poles (each 3½-inch diameter, 21 feet long).
The Pont-Neuf Wrapped, Project for Paris, in progress.

1977–78

Wrapped Walk Ways, Loose Park, Kansas City, Missouri.
15,000 square yards of woven nylon fabric over 4.5 kilometers of walkways.

1979

The Mastaba of Abu Dhabi, Project for the United Arab Emirates, in progress.

1980

The Gates, Project for Central Park, New York City, in progress.

1980–83

Surrounded Islands, Biscayne Bay, Greater Miami, Florida, 6½ million square feet pink woven polypropylene fabric.

1985

The Umbrellas, Project for Japan and Western U.S.A., in progress.
The Pont-Neuf Wrapped, Paris, 1975–1985.
Married: Jeanne-Claude de Guillebon. Son: Cyril, born 1960.

BOOKS

1965

Christo. Texts by David Bourdon, Otto Hahn, and Pierre Restany. Designed by Christo. Edizioni Apollinaire, Milan.

1968

Christo: 5600 Cubic Meter Package. Photographs by Klaus Baum. Designed by Christo. Verlag Wort und Bild, Baiersbronn, West Germany.

1969

Christo. Text by Lawrence Alloway. Designed by Christo. Harry N. Abrams, Inc., New York.

1969

Christo: Wrapped Coast, One Million Square Feet. Photographs by Shunk-Kender. Designed by Christo. Contemporary Art Lithographers, Minneapolis.

1970

Christo. Text by David Bourdon. Designed by Christo. Harry N. Abrams, Inc., New York.

1971

Christo: Projeckt Monschau, by Willi Bongard. Verlag Art Aktuell, Cologne.

1973

Christo: Valley Curtain. Photographs by Harry Shunk. Designed by Christo. Harry N. Abrams, Inc., New York.

1975

Christo: Ocean Front. Text by Sally Yard and Sam Hunter. Photographs by Gianfranco Gorgoni. Edited by Christo. Princeton University Press, Princeton, New Jersey.

1977

Christo: Running Fence. Text by Werner Spies. Photographs by Wolfgang Volz. Harry N. Abrams, Inc., New York.

1978

Christo: Running Fence. Chronicle by Calvin Tomkins. Narrative text by David Bourdon. Photographs by Gianfranco Gorgoni. Designed by Christo. Harry N. Abrams, Inc., New York.

1978

Christo: Wrapped Walk Ways. Essay by Ellen Goheen. Photographs by Wolfgang Volz. Designed by Christo. Harry N. Abrams, Inc., New York.

1982

Christo—Complete Editions 1964–82. Catalogue Raisonné and Introduction by Per Hovdenakk. Verlag Schellmann und Kluser, Munich, and New York University Press, New York.

1984

Christo: Works 1958–83. Text by Yusuke Nakahara. Sogetsu Shuppan, Inc., Tokyo.

1984

Christo: Surrounded Islands, Biscayne Bay, Greater Miami, Florida, 1980–83. Text by Werner Spies. Photographs and editing by Wolfgang Volz. Dumont Buchverlag, Cologne.

1984

Christo—Der Reichstag. Compiled by Michael Cullen and Wolfgang Volz. Suhrkamp Verlag, Frankfurt.

1985

Christo. Text by Dominique G. Laporte. Art Press/Flammarion, Paris. English edition by Pantheon Books, New York, 1986.

1985

Christo: Surrounded Islands, 1980–1983. Text by Werner Spies. Photographs and editing by Wolfgang Volz. Harry N. Abrams, Inc., New York.

CATALOGUES FOR EXHIBITIONS (SELECTED)

1961

Galerie Haro Lauhus, Cologne. Text by Pierre Restany.

1966

Stedelijk van Abbemuseum, Eindhoven, Netherlands. Text by Lawrence Alloway.

1968

Museum of Modern Art, New York. Text by Prof. William Rubin.

1968

I.C.A. University of Pennsylvania, Philadelphia. Text by Stephen Prokopoff.

1969

National Gallery of Victoria, Melbourne. Text by Jan van der Marck.

1971
Haus Lange Museum, Krefeld, West Germany. Text by Dr. Paul Wember.

1973
Kunsthalle, Düsseldorf. Text by John Matheson.

1974
Musée de Peinture et de Sculpture, Grenoble. Text by Maurice Besset.

1975
Galerie Ciento, Barcelona. Text by Alexandre Cirici.

1977
Minami Gallery, Tokyo. Text by Yusuke Nakahara.

1977
Annely Juda Fine Arts, London. Texts by Dr. Wieland Schmied and Prof. Tilmann Buddensieg.

1978
Galerie Art in Progress, Munich: "Galerien Maximilianstrasse." Text by Albrecht Haenlein.

1978
Rijksmuseum Kroller-Muller, Otterlo, Netherlands. Introduction by R. Oxenaar and text by Ellen Joosten.

1979
Wiener Secession. Text by W. Spies. Introduction by H. J. Painitz.

1979
ICA, Boston. Introduction by Stephen Prokopoff. Text by Pamela Allara and Stephen Prokopoff.

1981
Museum Ludwig, Cologne. Introduction by Karl Ruhrberg and Klaus Gallwitz. Text by Evelyn Weiss and Gerhard Kolberg.

1981
Juda-Rowan Gallery, London. Texts by Christo and Anitra Thorhaug.

1981
La Jolla Museum of Contemporary Art, La Jolla, California: "Christo: Collection on Loan from the Rothschild Bank AG, Zurich." Introduction by Robert McDonald and text by Jan van der Marck.

1984
Satani Gallery, Tokyo: "Christo—The Pont-Neuf Wrapped, Project for Paris." Text by Yusuke Nakahara; interview by Masahiko Yanagi.

1984
Annely Juda Fine Arts, London: "Christo: Objects, Collages, and Drawings, 1958–83."

FILMS
1969
Wrapped Coast. Blackwood Productions.

1972
Christo's Valley Curtain. Maysles Brothers and Ellen Giffard.

1977
Running Fence. Maysles Brothers—Charlotte Zwerin.

1978
Wrapped Walk Ways. Blackwood Productions.

1985
Islands. Maysles Brothers—Charlotte Zwerin.

1986
The Pont-Neuf Wrapped. Maysles Brothers, in progress.

AUSTRALIA

Canberra
National Gallery of Art

Sydney
National Gallery
Power Institute of Fine Arts

AUSTRIA

Linz
Neue Galerie der Stadt Linz, Wolfgang Gurlitt Museum

Vienna
Museum of the Twentieth Century

DENMARK

Humlebaek
Louisiana Museum of Modern Art

ENGLAND

London
Tate Gallery
Victoria and Albert Museum

FRANCE

Grenoble
Musée de Grenoble

Marseilles
Musée Cantini

Nîmes
Musée de Nîmes

Paris
Centre National d'Art Contemporain
Centre National d'Art et de Culture Georges Pompidou
Musée d'Art Moderne de la Ville de Paris

Toulon
Musée de Toulon

IRAN

Teheran
Museum of Modern Art

IRELAND

Dublin
National Gallery

ISRAEL

Jerusalem
Israel Museum

JAPAN

Fukuoka
Fukuoka Art Museum

Iwaki
Iwaki Art Museum

Osaka
National Museum of Art

Shiga
Museum of Modern Art

Tokyo
Hara Museum of Contemporary Art
Seibu Museum of Art

Toyama
Museum of Modern Art

NETHERLANDS

Amsterdam
Stedelijk Museum

Eindhoven
Stedelijk van Abbemuseum

Otterlo
Rijksmuseum Kröller-Müller

Rotterdam
Boymans van Beuningen Museum

NORWAY

Oslo
Sonja Henie—Niels Onstad Foundation

SWEDEN

Stockholm
Moderna Museet

SWITZERLAND

Basel
Kunstmuseum Basel

Bern
Kunst Museum

Zurich
Kunstgewerbemuseum der Stadt
Kunsthaus

UNITED STATES

Albuquerque
Museum of Albuquerque

Ann Arbor
University of Michigan Museum of
Art

Boston
Fogg Museum

Bridgeport (Connecticut)
Housatonic Community College Museum

Brunswick (Maine)
Bowdoin College Museum of Art

Buffalo
Albright-Knox Art Gallery

Chattanooga
Hunter Museum of Art

Chicago
Art Institute of Chicago
Museum of Contemporary Art

Cleveland
Cleveland Institute of Art
Cleveland Museum of Art

Dallas
Dallas Museum of Fine Arts

Des Moines
Des Moines Museum

Greenville (South Carolina)
Greenville County Museum

Hanover (New Hampshire)
Dartmouth College Museum

Houston
Museum of Fine Arts

Jackson
Mississippi Museum of Art

Kansas City (Missouri)
Atkins Museum of Fine Arts

La Jolla (California)
La Jolla Museum of Contemporary
Art

Miami
Lowe Art Museum, University of Miami
Miami-Dade Community College Museum

Minneapolis
Walker Art Center

New Britain (Connecticut)
New Britain Museum of American Art

New Haven
Yale University Art Gallery

New York
Museum of Modern Art
Whitney Museum

Northampton (Massachusetts)
Smith College Museum of Art

Oberlin (Ohio)
Allen Memorial Art Museum

Philadelphia
Museum of Fine Arts

Richmond
Virginia Museum of Fine Arts

St. Louis
City Art Museum of St. Louis

St. Paul
Minnesota Museum of Art

San Francisco
San Francisco Museum of Art

Santa Barbara
Santa Barbara Museum

Soquel (California)
Art Museum of Santa Cruz County

Worcester (Massachusetts)
Worcester Art Museum

WEST GERMANY

Aachen
Neue Galerie der Stadt

Berlin
National Galerie

Bonn
Rheinisches Landesmuseum

Cologne
Ludwig Museum
Wallraf Richartz Museum

Frankfurt
Deutsches Architektur Museum

Hamburg
Kunsthalle Hamburg

Hanover
Kunstmuseum

Krefeld
Kaiser Wilhelm Museum

Munich
Neue Pinakothek

Stuttgart
Kunstverein
Staatsgalerie

"Frontiers" is the title of the complete text of a conference held on May 14, 1981 at the Ecole Nationale des Ponts-et-Chaussées, and repeated for the benefit of the Association de Diane at the Musée Sainte-Croix in Poitiers and the Centre d'Art Contemporain in Chateauroux. The text was previously published in Art Press, number 68 (March 1983).

"Miami Water Lilies," a text written at the request of Catherine Issert for the French presentation of Surrounded Islands, was published in the journal Picture, number 2 (Autumn 1983).

Two chapters—"The Veil" and "The Shroud and the Name"—were published separately in Picture, number 3, an issue devoted to the question of the "veil" (Toulouse, 1984).

The description of Wrapped Kunsthalle, Bern, Switzerland, 1968 by David Bourdon is excerpted from his Christo, published by Harry N. Abrams, Inc., New York, in 1970. Copyright © by Harry N. Abrams, Inc., Publishers.

All written material by Christo courtesy of and Copyright © by Christo.

ABOUT THE AUTHOR

Dominique G. Laporte was born in Tours, France, in 1949. Poet, art historian, and Flaubert scholar, he taught at the University of Paris and completed his advanced studies in psychoanalysis under Jacques Lacan. He was a frequent contributor to literary reviews, and the author of a number of books of fiction, essays, psychoanalytic theory, and art history. He died in November 1984.